Transnational Black Feminism and Qualitative Research

T0332360

Transnational Black Feminism and Qualitative Research invites readers to consider what it means to conduct research within their own communities by interrogating local and global contexts of colonialism, race, and migration.

The qualitative data at the center of this book stem from a yearlong qualitative study of the lived experiences of Black women, who migrated to or spent a significant amount of time in the United States, as well as from the author's experiences as a Black German woman and former international student. It proposes Transnational Black Feminism as a framework in qualitative inquiry. Methodological considerations emerging from and complementary to this framework critically explore qualitative concepts, such as reciprocity, care, and the ethics with which research is conducted, to account for shifts in power dynamics in the research process and to radically work against the dehumanization of participants, their communities, and researchers.

This short and accessible book is ideal for qualitative researchers, graduate students, and feminist scholars interested in the various dimensions of racialization, coloniality, language, and migration.

Tanja J. Burkhard is a qualitative researcher and Assistant Professor of Human Development at Washington State University. Her work centers the intersections of the areas of qualitative research, Black feminist praxis, and (im)migration.

Developing Traditions in Qualitative Inquiry
Series Editors: Jasmine Brooke Ulmer and James Salvo
Wayne State University

The Developing Traditions in Qualitative Inquiry series invites scholars to share novel and innovative work in accessible ways, ways such that others might discover their own paths, too. In acknowledging who and what have respectively influenced our work along the way, this series encourages thoughtful engagements with approaches to inquiry – ones that are situated within ongoing scholarly conversations. Neither stuck in tradition nor unaware of it, volumes make new scholarly contributions to qualitative inquiry that attend to what's shared across disciplines and methodological approaches. By design, qualitative inquiry is a tradition of innovation in and of itself, one aimed at the target of justice.

From multiple perspectives and positionalities, concise volumes in this series (20,000 to 50,000 words) strengthen and grow the qualitative community by developing inquiry traditions as they should be developed: inclusively, diversely, and together.

For more information about the series or proposal guidelines, please write the Series Editors at jasmine.ulmer@wayne.edu and salvo@wayne.edu.

Other volumes in this series include

Transnational Black Feminism and Qualitative Research
Black Women, Racialization and Migration
Tanja J. Burkhard

Writing and Unrecognized Academic Labor
The Rejected Manuscript
James M. Salvo

Centering Diverse Bodyminds in Critical Qualitative Inquiry
Edited by Jessica Nina Lester & Emily A. Nusbaum

Evocative Qualitative Inquiry
Writing and Research Through Embodiment and the Poetic
Joanne Yoo

For a full list of titles in this series, please visit www.routledge.com/
Developing-Traditions-in-Qualitative-Inquiry/book-series/DTQI

Transnational Black Feminism and Qualitative Research

Black Women, Racialization and Migration

Tanja J. Burkhard

Routledge
Taylor & Francis Group

LONDON AND NEW YORK

First published 2022
by Routledge
2 Park Square, Milton Park, Abingdon, Oxon OX14 4RN

and by Routledge
605 Third Avenue, New York, NY 10158

Routledge is an imprint of the Taylor & Francis Group, an informa business

British Library Cataloguing-in-Publication Data
A catalogue record for this book is available from the British Library

Library of Congress Cataloging-in-Publication Data
Names: Burkhard, Tanja, author.
Title: Transnational Black feminism and qualitative research : Black
 women, racialization and migration / Tanja J. Burkhard.
Description: Milton Park, Abingdon, Oxon ; New York, NY : Routledge,
 2022. | Includes bibliographical references and index.
Identifiers: LCCN 2021040376 (print) | LCCN 2021040377 (ebook) |
 ISBN 9780367521165 (hardback) | ISBN 9781032199146 (paperback) |
 ISBN 9781003056621 (ebook)
Subjects: LCSH: Black women—Research. | Social sciences—Research.
Classification: LCC HQ1163 .B87 2022 (print) | LCC HQ1163 (ebook) |
 DDC 305.48/896072—dc23
LC record available at https://lccn.loc.gov/2021040376
LC ebook record available at https://lccn.loc.gov/2021040377

ISBN: 978-0-367-52116-5 (hbk)
ISBN: 978-1-032-19914-6 (pbk)
ISBN: 978-1-003-05662-1 (ebk)

DOI: 10.4324/9781003056621

Typeset in Times New Roman
by Apex CoVantage, LLC

Contents

Acknowledgments

I am deeply grateful to my mentor Dr. Valerie Kinloch, who not only guided me through graduate school but also opened up this pathway to me and countless others. Along with the members of my dissertation committee – Dr. Mytheli Sreenivas, Dr. Candace Stout, and Dr. Cynthia Tyson, you provided me with feedback and support on the project that is at the center of this book, and I am grateful to each one of you for your labor on my behalf. Thank you, James Salvo, Jasmine Ulmer, and Hannah Shakespeare, for your work on this volume, for your guidance, and for allowing me to learn from you. I also thank the 2020 Science as a Story Fellowship group for providing the feedback on my creative nonfiction writing.

I continue to be in awe of the resilience, care, and love I experienced from the women around me, particularly the women who contributed their stories to this work – Ama, Chrisette, Maya, Marisha, Naima, and Tee, thank you for your wisdom. Thank you, Dr. Youmna Deiri for your affirmation, inspiration, and brilliance. I also write these acknowledgments in deep gratitude to Dr. Marcelo Diversi, not only for being an exemplary mentor and advocate, but also for providing reminders of taking rest and breathe in times when neither seemed possible. To Nia, Marcus, my parents Sharon and Leo, and my grandparents Leo, Hilde, Hilred, and Clifton, I thank you for being my North Star while I am farther away from any "home" than ever before. In gratitude to Black women whose words, wisdoms, and deeds reverberate through my life.

Introduction
Bursting American dreams

The first time I came to the United States, it was to visit friends. A few months shy of my 18th birthday, I remember looking at the piles of clouds outside of my window with untarnished excitement. Based on what I had learned about the United States from the U.S. military folks stationed near the small town in Germany I grew up in, I had high expectations. I just knew the food would taste better than anything I had ever tasted, the buildings would be taller and more beautiful than I had ever laid eyes on, and the clothes always praised by my German grandmother, who worked as a maid in an American household, would be superior. When I landed and it was my turn to go through immigration procedures, it was noted that I had failed to fill out the address information correctly and was guided to a small room and confronted by a group of armed personnel. I was asked what my "endgame" was – sex work or terrorism. During 2 hours of interrogation, and being threatened of being sent home on the next flight, I explained my situation and produced my friend's phone number from memory. When I was finally sent on my way, I not only was sweaty and exhausted, but also realized that I could no longer conjure up the heavenly tastes, smells, and images that had been my imagination of "America" just a few hours before.

I spent each night of my visit there riddled with nightmares of being interrogated, suspected of crimes, and tortured. This was a place where a small mistake, or even no mistake, could land you in a world of recurring nightmares. When I recounted the story to my father, he recalled that when my mother migrated to Germany, 19 years before my experience, suspicions about her "intentions" for coming to Germany were also brought up to him by the clerk who officiated their wedding. Thus, when I returned years later to pursue my graduate education in the United States, I realized that any research I would conduct would occur against the backdrop of the dreams of safety, opportunity, futurity and the nightmares of the violent extensions of chattel slavery, colonialism, and the carceral state that make America. This book extends transnational feminist and Black feminist approaches in qualitative inquiry. The study from which I draw to explore the methodological implications that emerge from this perspective presented a set of theoretical and methodological challenges, as it was conducted during a time of rhetorical shifts in U.S. political discourse about who the immigrant, migrant, and undocumented people are; what they want; and how to best respond to them. At the same time,

DOI: 10.4324/9781003056621-1

conversations with Black women who migrated to the United States as adults also revealed how they were required to make sense of anti-Black racism and the particular marginalization and oppression of Black women and their outgrowths in the United States, as well as how these processes impacted their self-identification and racialization. Each of the participants, including myself, were reckoning with the impact of this rhetoric on our own lives and leaned on each other for support in the process.

The United States' history of centuries of dehumanization and oppression with respect to African American people specifically and Black people more generally revealed itself in old and new ways through the shootings of unarmed Black men and women, the excessive policing of the communities they lived in, and the many other extensions of chattel slavery. At the time, I was an international student, who had originally come to the United States through an exchange program. Every conversation with the women who had participated to be interviewed for my study felt worthy of being contextualized and analyzed more broadly, as they revealed much about the ways contexts of (settler) colonialism, White Supremacy, and xenophobia coalesced to shape and create both mundane and extraordinary issues in the research itself, in the relationships between myself and the participants, and our everyday lives. With the increase in deportations, the executive order dubbed as the Muslim ban, and a rhetoric that reinforced an America-first approach, the participants, Ama (Ghanaian-German), Haki (Kenyan), Marisha (Jamaican), Chrisette (Haitian), Naima (Somali), Maya (Jamaican), and I (Jamaican-German), who come from different countries of origin, educational and class backgrounds, often felt ourselves under siege. In addition to centering our lived experiences, knowledges, and shifts in our identities as women who had all migrated to the United States as adults, it was my goal to conduct research that was methodologically sound and reflexive with respect to the possibilities of violence that may be exerted through the process of collecting stories and experiences often marked by pain and danger. Throughout the process of collecting data, seeking to attend to the shifting contexts and discourses and navigating these emotions alongside my community – my friends, family, and research participants – I recognized that the traditional qualitative methods I had studied in graduate school had not prepared me for representing these contexts as comprehensively and dynamically as I felt would be necessary. Although I was to position myself in the research, I was unsure where to position my own stories of pain, turmoil, and despair. And at the end, it was a challenge to represent narratives of women, some of whom were already going through so much, in ways that not only were ethical from an institutional perspective, but also honored our relationship, which often was the one bond that we could rely on for support.

I posit that studies of the lived experiences of migrants, Black people, and Black migrants require the careful analysis of the totalizing forces of colonialism and settler colonialism that shape these lived experiences. Qualitative researchers who are based in the United States, then, must inevitably study the histories and contexts from which their participants originate, as well as develop a sound understanding of the United States as a settler colony and their positioning within

it. Current articulations of transnational Black feminist scholarship (Okpalaoka & Dillard, 2012; Hall, 2019; Burkhard, 2019) point to the need of engaging Black Feminist Frameworks that attend to the global and transnational dimensions of Black women's lives and lived experiences.

A transnational Black Feminist approach to qualitative research marries Black feminist practice and transnational feminism to produce a methodological and theoretical lens that both attends to the particular lived experience of Black women, as well as considerations of colonization and the pursuit of anti-colonial practices throughout the conceptualization, implementation, and presentation of research. Any such work, however, is required not only to contend with the genealogies of the feminist scholarship from which these ideas emerge, but also to work to de-essentialize hegemonic ideas about Blackness and womanhood, and consequently Black womanhood. Describing Black feminism as "a critical social theory born out of the lived experiences of Black women", Venus Evans Winters (2019) notes that "Black feminism as a tradition of Black women's intellectual thought is devalued and marginalized in qualitative methods courses and textbooks" (p. 17). In this way, this book offers a further intervention of texts that value and critically contextualizes Black women's ways of knowing by placing them front and center in the qualitative research process. Furthermore, a transnational Black feminist approach additionally offers an intervention in the oftentimes U.S.-centric ways of understanding Black women's lived experiences. Rather than placing U.S. Black women's histories and experiences in contrast or contention with those of Black transnational and immigrant women, it is my hope to use the stories, poetics, and knowledges of Black women born outside of the United States to build and develop intimacies (Nash, 2018) among Black women across differences. This development of intimacies, I argue, requires the thoughtful and careful engagement of each other's stories.

Chapter 1 theorizes Transnational Black Feminism (TBF) as a theoretical and methodological framework. In building this framework, I will trace the historical contexts that have contributed to and shaped migration in my own life as the granddaughter of a Black Jamaican woman and descendent of slaves, who worked in Canada of the early 1970s as part of the service economy. Her child, my mother, then moved to Germany after meeting my father in the early 1980s, and I, in turn, moved to the United States in the mid-2000s. My grandmother's transnational work was primarily a result of the economic instability in Jamaica, which was a long result of imperialist and colonial policies and practices that left the descendants of slaves faced to contend with the poverty, political upheaval, and lack of economic mobility. Going abroad to work was and continues to be one of the ways in which Caribbean peoples are able to sustain themselves and their families. My mother's decision to remain in Germany also had economic and future-making reasons, since the situation had not changed much by the 1980s. In turn, I was prompted by my lived experiences as a Black German woman steeped in "Otherness" and static foreignness (El-Tayeb, 2011) to pursue my graduate studies in the United States. Considering the histories, contexts, and layers in my own background, particularly as they relate to racialization, interactions with

nation-states, and the legacies of colonialism, is a requirement for adequately locating myself in the research. This positioning includes and extends beyond notions of insider/outsider discourses (Couture, Zaidi, & Maticka-Tyndale, 2012) or concepts, such as translocational positionality (Anthias, 2008), and allows me to – at least in part – understand the "betweener" knowledges (Diversi & Moreira, 2009) that I bring to the research process.

Chapter 2 begins with a narrative that excavates some of the tensions that arose between my formal instruction regarding qualitative methods and my lived experience in getting to know Chrisette, one of the participants. Thus, this chapter extends the implications of the personal narrative and attention to positionality presented in Chapter 1 to the larger study explored in the book and introduces the participants and their respective contexts. The study was conducted with one woman from Somalia who had been through a resettlement process; two women who did not have documentation at the time of data collection (from Haiti and Jamaica, respectively); one woman from Germany, with Ghanaian parentage, who lived in the Midwest of the United States; one woman from Jamaica, who came on a work visa to teach Middle School in the South of the United States; and one woman, whose African American father was in the U.S. military and who spent half of her year in the United States and the other half in Germany. All of the women speak various languages and have different educational backgrounds, and their interactions with various governmental agencies vary depending on their visa/immigration status. Chapter 3 puts the transnational Black feminist approach outlined in Chapter 1 overview to work. It draws on the women's collective, yet specific experiences to show the ways in which the analysis of the data required an approach that a Transnational Black Feminist approach.

Chapter 4 explores the concepts of reciprocity and power by thinking through some of these dynamics with the example of Chrisette. Relationships are central to many approaches to qualitative inquiry conducted by minoritized researchers (Boylorn, 2013; Deiri, 2018). Of course, relationships differ between each set of persons. Continuing the story of Chrisette, Chapter 4 considers the importance of reciprocity in feminist and postpositivist approaches to qualitative research (Weems, 2006). More specifically, it tells stories in which the concept of reciprocity, deeply tied to the relationship between the researcher, the participant/friend, and the material context, became a site of struggle, contention, and learning for all parties involved. Thus, it is necessary not only to reflect on the role of reciprocity in each research endeavor, but also to critically question how we take it up.

The conclusion presents the end of the stories of the focal participants (Chrisette and Naima) by highlighting the ways they were shaped by the larger contexts of colonialism, as well as contemporary understandings and contexts related to race, gender, and migration. The conclusion invites the reader to engage in reflexive practices that engage both the storytelling in the book as well as its implications for qualitative inquiry.

1 Building a methodological framework

Toward transnational Black feminist inquiry

America

The U.S. is good. –
It has all these things –
Opportunity –
I get a job.
I got married –
Everything is so convenient
There is water
when you want it
There is electricity
There is everything –
The sky's the limit
But there's still something –
that is missing
We have income –
We have jobs
And we still have stress
That busy lifestyle is not so good –
I feel like I've lost
a lot of my culture
That humanness is not there –
You're suffering
by yourself and
nobody cares
(Data Poem "America" Words by
Naima, Haki, Marisha)

I initially merged the voices of the participants in my yearlong qualitative inquiry into the lived experiences of Black transnational women into data poems (Glesne, 1997), after recognizing the poetics in the timbre of their voices, their speech, and their storytelling as I listened to interview data over and over again. Naima, Haki, and Marisha, whose voices are merged in the poem titled "America," come from different parts of the world. Naima is from Somalia, Haki from Kenya, and

DOI: 10.4324/9781003056621-2

Marisha from Jamaica. They do not share the same educational backgrounds, but they do share an experience of "America" as well – and all of its tensions – as Black women who have been here for varying lengths of time. "America," in their words, offers opportunity but demands sacrifice. Marisha and I share grandparents as first cousins, though we grew up in different countries. I recall spending summers with her and many of our other cousins, as I struggled to communicate in English, sometimes by drawing pictures, sometimes by charades, and sometimes giving up – feeling inadequate.

In Germany, where I grew up, I had no cousins or family members of my age. As the only child of color in my school, who was also painfully shy, I was always out of place. My mother was often also the only Black woman in her educational and leisure spaces, but she held her head high, even when she experienced violence and terror. She reminds me frequently that Germany (and Switzerland, where she now lives) are not her home, but rather temporary spaces she navigates. There is a special type of resilience, which she draws from her knowledge that there exists a small plot of land and a house that she took years to build from abroad surrounded by her siblings, nieces, and nephews to which she can return if life in Europe becomes too much to bear. The vision of this home that despite all of its changes continues to embrace her with the warmth of familiarity is not familiar to me. When my mother shares it, in bits and pieces, I wonder what it must feel like to have a physical and imagined place to which one can return or escape – to walk down the street and be recognized by neighbors, family members, and friends the way my mother is in her home village, no matter how long she was away. I am certain that my mind has glorified this notion of home to which I have no access, but my mother always confirms: "Yes, it is beautiful."

Tracing (grand)mother's stories

In an interview with Naima shortly before the U.S. presidential elections of 2016, she pointed to our difference from her perspective, which is that if the situation in the United States were to become worse for immigrants, I could always return to my home country, while she did not see the option of returning to Somalia without feeling unsafe and without the possibility of envisioning a successful future. I started thinking about this idea of "home" and what a contested imaginary and physical space it could be. I had just returned from a trip to Jamaica, where my mother and her siblings had discussed aspects of my maternal grandmother's life that I had not previously heard about. The fragmented lived experience recalled and shared by grandma Hildred's children reminded me that the experiences of being severed from home, of migrating for one's own survival or the survival of one's children, and the economic and educational power of North America in the lives of myself, Naima, Haki, Marisha, and the other participants are only extensions and continuations of the experiences of many of our foremothers.

I work to retell the fragmented bits of my grandmother's story here, both as an act of remembrance as well as to illustrate one way to think about daughtering (Evans-Winters, 2019) and by extension of piecing together the fragments of lived

experiences, "granddaughtering" in qualitative inquiry. Citing Dillard (2012) and Errante (2000), Rhee (2021) argues that "academic knowledge, training, and expertise or credentials, more often than not seduce us to forget. . . . I forgot how to listen to my own m/other" (p. 17). As for Rhee, many feminist of color writers consider relationships with mothers and motherhood as a central aspect of exploration. However, having been raised in the same household with one grandmother and in total absence of another, I recognize the ways the stories of our mother's mothers can impact our lives. In many ways, their stories are not only windows into different times, but they also provide context for our own mother's ways of knowing their desires and their journeys. Carol Boyce Davies writes "my mother's journeys redefine space. Her annual migrations between the Caribbean and the United States, are ones of persistent re-membering and re-connection" (1995, p. 1).

Similarly to Davies' mother, my mother spends life between two worlds, Switzerland and Jamaica, different versions of her coming to life in the various spaces. During her travels, she switches from Swiss German, to High German to Patois, and Jamaican Standard English in the matter of hours. She spends hours on the phone remembering and reconnecting with her siblings in various parts of the world. Sometimes, when I call from across the world, she calls me by her sister's name first, as she always has, laughing off the mistake she has been making since I can remember. I have always recognized these moments as being ruptures in space and time, moments in which my mother occupies all of her selves and remembers banter and levity with her sister in times before they were regaled to sometimes tense visits throughout the year. Each time she returns from a visit to home, a sad longing feeling washes over her to go back as soon as possible. She often recalls withering away during her first year as a young woman in Germany, homesickness rendering her unable to eat and be active. Her own mother, my maternal grandmother, Hildred died in a small village outside of Ocho Rios, Jamaica, when my mother was only 11 years old. I have heard fragments of her story throughout my life, some as cautionary tales, and in the praises sung to this woman, who loved education so much that she would herd the neighborhood children into a room over the summer to combat what we now call "summer learning loss." Her untimely death, at the age of 35, has been a cornerstone of caution, not only in my life, but also in the lives of Marisha and Maya, who are both my first cousins (and participated in my research project). My mother always reminded me of the importance of life insurance in case she would not live beyond 35 years of age and admitted that she had always assumed her passing would occur around the same age as her mother's. As the story goes, Hildred was an intelligent, deeply religious, book-smart woman from Kingston, Jamaica, who had made it as far as being admitted to a university in England in the late 1960s. Her own mother had vigorously fund-raised for her ship fare, but she met my grandfather and decided to pursue the relationship with him, rather than moving abroad. She bore eight children and went to work as a service worker in Canada in the midst of a financial crisis. Upon her return to Jamaica only 11 months later, she immediately became pregnant again and found out that the money she had carefully sent to her husband went to funding a different family's life. She

died very soon after giving birth to her youngest child. Her children scrambled to continue living, with none of them recovering from their loss. Hildred's story ricochets through our family. My own mother migrated from Jamaica to Germany after meeting my father, and has since moved to Switzerland, and I moved to the United States to pursue higher education. In each context, we are required to grapple with our position and social location as Black women, who are must make and re-make our homes, social networks, and memories in light of the geographical and sociopolitical landscapes we now navigate.

When I returned to the United States as an exchange student from Germany in the midst of the financial crisis of 2009, my university held an exchange program with several schools in the United States, including Middle Tennessee State University. I was thrilled not only at the prospect of teaching German, but also at the idea of potentially living in a community, which would be much more diverse than the German small towns in which I had grown up and attended university. However, once thrust into the South of the United States, I did not only have to navigate this new country and context, but also had to reckon with the local and global histories of enslavement, racialization, and continued de facto segregation. I was so ignorant. Several students in my classes voiced that I did not embody what they had envisioned a competent German instructor to look like and assumed that I was an American who had studied German and was therefore less competent than my colleague, who was happy to wear the traditional garb of her home, Bavaria. Although I lacked the language, I knew that racialized readings of my body were intimately attached to presumed competence or incompetence further underlined by the assumption that I was not a "native speaker." It turned out that the "Otherness" that I had become so intimately aware of growing up in Germany became more complicated in this new setting, as the assumptions about me were always intimately tied to my capability and competence, even if translated differently in each context.

When I heard snippets of these ideas repeated by other Black women over the years, I started to wonder what it meant to collect and center their stories – our stories – and to consider the transnational dimensions that shape them. For me, growing up in the 1980s, 1990s, and early 2000s in Germany meant that my access to understand what Blackness was, was framed by American exports in film and music, as well as the anti-Black discourses and narratives that circulated around my region, the Southwest, in which many U.S. military bases still remain in existence. Derogatory terms, such as "war baby" and "Mischling" (mutt), were often applied to those of white German and Black parentage, even if neither parent had served in the military. I navigated educational and private spaces as the only person of color, with only my mother as a point of reference for how to understand race and racism. While my school curricula heavily emphasized discussions of anti-Semitism in the Third Reich and chattel slavery in the United States, understandings of Black Germanness were never included. In my schooling experience up to the ninth grade, I often heard of eugenicist myths related to the supposed deficient cognitive capacity of people of African descent and, at times, began internalizing

these myths that were presented as biological facts (and had been long proven to be false). The remarkable work done by Katharina Oguntoye and Audre Lorde, for instance, in their 1986 book *Farbe bekennen* and May Ayim's (1995) *Blues in schwarz-weiß* and many others organizing on behalf of Afro-Germans and Black Germans in the 1980s and 1980s were not included in the curricula, and I did not learn about the existing transnational Black feminist organizing until I came to the United States for graduate school. In recent years, race and racialization in Europe have garnered attention. I recognize that growing up within this space of overwhelming presence of whiteness (Sleeter, 2001) differed in experience from the participants in this study. In this work, I seek to attend to this difference and points of departure along with understanding the many overlaps.

Qualitative researchers, who are invested in the knowledges, ways of being, and stories of their participants, are inevitably faced with the question of what it means to interpret and render the complexity and multilayered nature of someone's lived experiences in ways that are comprehensible for the reader without being reductive and in ways that are careful and reflexive, without obscuring the knowledges produced by projecting one's own lens.

Working with and for communities of color, generally, and Black immigrant communities, specifically, inevitably also requires a reckoning with how contexts of globalized White Supremacy, xenophobia, and anti-Black ideologies are shaping not only the lives of our research participants, young and old, but also our lens of interpretation, our own notion of what is worthy of study, what we include and discard, and why. It requires of us to not only know how to conduct sound qualitative research by asking the right questions, but also understand all of the contexts – historical, geographic, and sociopolitical – that help us to determine what the right questions are and what answers we feel ready and able to interpret and make legible to readers. What do we make of the stories of our participants, and what do we make of the stories of ourselves in relation to those of our participants, our communities, and our ancestors? As a researcher, I have found that it is in the stories of that echo throughout our lives, sometimes as cautionary tales, at times as wisdom to be carried forth from generation to generation, often make sites of wonder, friction, curiosity, and familiarity when they are placed in relation to those of others. The remainder of this chapter offers a review of literature on Black immigrants in an effort to work toward a Transnational Black Feminist Framework for qualitative inquiry.

Black immigrants in the United States

The first time I encountered Naima. At the time, she was 29 years old[4] and proud to know her age, which she later noted, because in her home country of Somalia, it was not common that birth records were produced and retained in the 1980s, when the country was already wrought with civil war, which destroyed institutions. After being referred by their teacher, I met Naima and her friend for English tutoring in the lobby of a local community college, at which they both were

taking a writing class at the time. I entered the lobby later than I had wanted to and was immediately greeted with warm embraces from both women. I recall feeling naked next to them due to my exposed arms, although just a moment before, I had been grateful for not wearing long sleeves in the heat of August. We immediately started chatting, and it wasn't long before Mariam showed me pictures of her children, her husband, and quite a few selfies on her phone. She asked to see my family, and since I was single at the time, I produced images of my Black Jamaican mother and my white German father. I recall her saying loudly (and having repeated it quite a few times since) "Oh, look at your mother! She is darker than me! I thought you were like Mexican."

The experiences of Black immigrants in general have not been the focus of many research studies. The few studies that do exist, however, often fail to explicitly discuss who counts as Black, an identity marker that has been reclaimed and politicized by African American writers and scholars from various schools of thought (Gordon, 2003; Essien-Udom, 1962), but may be contended by those who hail from countries that are so predominately populated by African peoples that marking oneself as Black has been unnecessary until one arrived in the United States. On the other hand, knowing that Blackness is subjugated in many spaces across the world – particularly due to the globalization of White Supremacy (Allen, 2001), with its manifestations in predominately Black spaces through colorism – can represent a marker of difference that is not readily accepted by those who are formally racialized as Black, for example, on the U.S. census. U.S. notions of Blackness oftentimes still operate based on the one-drop rule, which focuses on lineage rather than phenotype and which further complicates the notion of Blackness and Black identity.

In either case, claiming or not claiming Blackness can create tensions that are founded in cultural or ideological difference. However, I would argue, not explicitly engaging the term allows it to potentially function in unwanted ways, particularly if it determines the recruitment of research participants. For example in Moore's (2013) work, *The American Dream Through the Eyes of Black African Immigrants in Texas*, the author, who self-identifies as a Black immigrant, states that she collected qualitative data from "80 Black African immigrants regarding the American dream" (p. 5). Nevertheless, Moore fails to provide a discussion of whether or not the participants identified as Black, and, if so, what this identity meant to them.

Hodges (2005), on the other hand, notes that Blackness in the context of Black immigrants remains to be viewed through a U.S. lens, without a consideration of the very specific experiences, cultures, and backgrounds of those who are not descendants of the transatlantic slave trade. Relatedly, in his ethnographic work with African immigrant youths in Canada, Ibrahim (2014) explores the process of becoming Black. He asks various questions, including: "How does one make a *woman*, woman, or a Black person, *Black*? More importantly, what is the psychic and consequently ethnographic result of being made woman or being made

Black?" (p. 13). Although questions of the intersectional nature of race and gender are not addressed comprehensively throughout his text, he illustrates that his participants access Black English as a Second Language as a means to forge Black identity in a predominately white space. Blackness in this case, then, is largely defined by U.S.-American definitions.[1]

The population increase of Black immigrants in the United States from 80,000 in the 1980s to roughly 3.7 million in 2014 (Morgan-Trostle & Zheng, 2016) has prompted a small number of studies and books dedicated to Black immigrants as a population. These studies use both qualitative and quantitative approaches, and they employ a variety of theoretical frameworks. The population increase has also necessitated ongoing engagements with the notion of diaspora and Black identity, as they are at the center of these studies. Rahier, Hintzen, and Smith (2010) employ the concept of Black consciousness in order to theorize Black identities and knowledges as flexible and not bound by place. They note:

> Someone is "Black" not on the basis of being West Indian, or Jamaican, or African American, or African, or Black British but by the virtue of Black consciousness embedded in the materialities of the social, political, and cultural geography produced out of the universality of hegemonic ruling ideas of Supremacy inscribed through the violence of White commandment.
> (Rahier, Hintzen, & Smith, 2010, Introduction, p. xix)

This Black-consciousness-based and diasporic approach to understanding Blackness avoids the conundrum of theorizing Black identities and experiences through the nation, or country, of origin. Diaspora, then, constitutes a metaphor that creates a space in which identities and movement can be considered across the boundaries of nation-states. A diasporic Black identity is produced by the experiences with anti-Blackness and White Supremacy, while allowing the flexibility of difference. It allows for the recognition of the diversity of experiences with respect to social class, gender, and location, while centering a common place of origin (the imaginary of Africa) as a point of connection for organizing, providing resistance to systems of oppression, and understanding.

Konadu-Agyemang, Takyi, and Arthur (2006) also employ a diaspora-based approach in their edited volume entitled, *The New African Diaspora in North America*, which centers what they refer to as the "new African diaspora." The volume considers both the United States and Canada and employs a theoretical framing that is rooted in the concept of diaspora. They consider the concept of returning home, spiritually and physically, as well as the understanding that migration is based on patterns by Africans, which are shaped by "push forces" (unfavorable conditions in home country) and "pull forces" (other countries attract migrants from those countries).

The circumstances that prompt migration, according to Konadu-Agyemang, Takyi, and Arthur (2006), include "the lack of jobs, extreme poverty, political instability, military coup d'etats, ethnic conflicts, deteriorating socio-economic

fabric and natural disasters" (p. 14). They also note the role of the Structural Adjustment Programs of the World Bank and IMF as economic push factors that impacted Africa in the 1980s, particularly as they affected African economies. Their description of the new African diaspora in relation to African immigrants who were prompted to come to the United States between the 1970s and today excludes the descendants of former African diasporas and those whose ancestors were brought to the Caribbean and South America as part of the transatlantic slave trade, who are also now immigrating to the United States.

The central paradigm of "push–pull" factors is also echoed by Moore (2013), whose study of the American Dream from the perspective of African immigrants found that although research suggests that maximizing income through migration is a primary reason to leave one's home country, none of her participants cited economic reasons as their reasons for coming to the United States, many of whom sought to further their education. This idea disrupts dominant notions of the American Dream or America's attractiveness as a country that primarily has to do with economic benefits. Thus, the American Dream extends beyond the desire to attain economic advantages. Considering the small number of studies that take into account Black immigrant lives and experiences, even fewer studies focus on Black immigrants from the Caribbean or South America. However, a recent report entitled *State of Black Immigrants* (Morgan-Trostle & Zheng, 2016) highlights the challenges experienced by this population. The report defines a Black immigrant as:

> Any person who was born outside the United States, Puerto Rico or other U.S. territories and whose country of origin is located in Africa or the Caribbean. Where Census data is available, the definition of "Black immigrant" is any person who was born outside the United States, Puerto Rico or other U.S. territories and self-identified as "Black or African American alone" in 2000 and later U.S. Census Bureau surveys.
> (Morgan-Trostle & Zheng, 2016, p. 7)

Based on this definition, the institutional identity marker of "Black immigrant" is primarily related to birthplace or to self-identification based on U.S. notions of Black identity in the census. It also highlights some of the complicated relationships among the nation, race, and citizenship, a point that is echoed by scholarship on anti-Blackness (Dumas, 2016). Rahier, Hintzen, and Smith (2010) contend that the concept of diaspora can serve as a space of exploration with respect to how Black people engage their relationship with the nation-state and its ideological underpinnings. They argue that "diaspora was forged through the history of movement across local and national boundaries, giving rise to the need for flexible accommodation in the face of 'place-bound' fixity" (Introduction, p. xvii). The concept of diaspora, then, allows for the considerations of connections based on a Black consciousness that moves beyond the borders of the nation-state, while remaining within its borders or crossing them. It centers the common origins and culture from a shared homeplace, Africa, as well as shared experiences with violence,

White Supremacy, and oppression (Rahier, Hintzen, & Smith, 2010). Additionally, the notion of diaspora does not make connections based on a Black identity, per se, but rather based on a movement that centers a shared homeland, cultural heritage, and identity, despite the diversity that may reside within experiences.

Waters (1999) argues that "[a]rriving as a stranger in a new society, the immigrant must decide how he or she self-identifies, and the people in the host society must decide how they will categorize or identify the immigrant" (p. 44). Based on this assertion, identities are not only self-inscribed, but also institutionally imposed by governmental agencies and enforced by the nation-state. Ibrahim (2014) stipulates that Black immigrants undergo the process of becoming Black in North America. This process is mediated by the immigrants' appropriation of African American cultural expressions (e.g. rap music and hip-hop culture, African American language), which may occur in partial and decontextualized ways.

This decontextualization may stem from the lack of a race-based identity in the home country (meaning that race is not a defining factor, while social class, ethnic affiliation, or region may be more salient) or the dominance and impact of Black American music, culture, and fashion across the media from around the world.

Studies on Black immigrant adults and youth (Coleman-King, 2014; Ibrahim, 2014; Waters, 1999) that take first- and second-generation immigrants into consideration have shown how complex racialization can be when it comes to entering the cultural context of the United States in which Black culture is often synonymous with African American cultural experiences, and anti-Blackness is one of the organizing principles of violence and dehumanization. Given the impact of American film and media abroad, these messages about Blackness and the position of Black people in the system of White Supremacy are often subtly but firmly circulated before travelers or immigrants ever set foot onto U.S. soil. Waters (1999) notes that the West Indian participants in her study often used the qualifier of being West Indian, Jamaican, immigrant, or Black in order to highlight that they are different from African Americans. Thus, despite identifying as Black, they did not center their racial identity as a place of solidarity with African Americans; rather, "for most of them assimilation to Black America was downward mobility" (p. 63). This subtle distancing of Black immigrant identity from African American identity, particularly in order to elevate oneself, is a recurring theme in research on the identities of Black immigrants (Coleman-King, 2014; Rahier & Hintzen, 2014).

Indeed, research shows that Black immigrants who come to the United States are generally successful in educational and professional spaces when compared to their African American peers (Massey et al., 2007; Waters, 1999; Sakamoto, Woo, & Kim, 2010). However, as Coleman-King (2014) notes, this success usually declines in the second generation as "[t]heir increased integration into the U.S. social milieu stymies immigrants' optimism, work ethic, and ability to thrive within a system deluged by social barriers" (p. 21). Thus, the very process of becoming a Black American, including the oppressive forces that shape this particular identity, impacts Black youth of Caribbean descent.

The efforts of first-generation Black immigrants to distance themselves from Black Americanness as they seek to resist Black people's positioning as inferior in the face of White Supremacy usually falter in the face of the next generation. This discussion necessarily requires that I revisit, briefly, the concept 'transnational' as an identity marker that provides the space for a wider range of experiences than the term 'immigrant.'

Black immigrant/Black transnational

This final section explores the notion of "transnational" as a way to describe the identities, processes, and experiences of those who cross borders regularly. Pessar (2003) notes that much of U.S. immigration theory has produced and reproduced a "hegemonic narration of U.S. immigration and national belonging" (p. 23). Based on this hegemonic narration of history, European immigrants came to the United States, remained here, and built a successful nation-state. She points out that this dominant narrative erases the large number of European immigrants who returned home, and also that those who stayed did not necessarily give up their ties to their home countries but remained involved in them. The logic of U.S. citizenship when regarded this way, then, requires the erasure of that which does not align with American exceptionalism or the desire of those who come here to maintain their own identities, which may or may not be tied to other nation-states or cultural perceptions of their ethnicities, race, or identities overall. A transnational framework challenges this mono-directional way of conceptualizing immigration and migration, as it allows for considerations of the ties, cultural practices, and identities that are maintained, contested, imported, or muted in the context of analysis.

Coleman-King (2014) argues that "a transnational perspective allows us to move away from deterministic and static notions of Blackness to incorporate a wider array of diasporic realities" (p. 10). I would argue that by replacing the term "immigrant" with the term "transnational," possibilities for considering identities, experiences, and erasures are opened up that are often limited by who an immigrant is based on the law. For example, a college student on a student visa who resides in the United States for years is not an immigrant and, yet, may be required to reckon with similar issues of racialization and social positioning as a green card holder. Thus, I will henceforth employ the term transnational as an identity, rather than immigrant, in order to accommodate a wider range of experiences.

Toward transnational feminist inquiry

In *Black Feminism in Qualitative Inquiry* (2019), Venus Evans-Winters writes

> Black feminism in qualitative inquiry offers the opportunity to expose and challenge the complex relationship between science and domination; Black women's history of objectification; meta narratives and everyday folklore

and myths produced and proliferated by dominant institutions in reproducing inequality.

(p. 19)

Indeed, U.S. Black feminists may gaze back upon a long and rich history of Black feminist organizing and theorizing, often centering U.S.-American conditions, histories, and realities as the entry point into this important work. For instance the Combahee River Collective Statement (1986) states,

> Before looking at the recent development of Black feminism we would like to affirm that we find our origins in the historical reality of Afro-American women's continuous life-and-death struggle for survival and liberation, Black women's extremely negative relationship to the American political system (a system of white male rule) has always been determined by our membership in two oppressed racial and sexual castes.

In many ways, then, the Statement not only offers an entry point into critiquing the U.S. nation-state, but also affirms the position of African American women at the epicenter of Black feminist theorizing. Given the historical specificity of the U.S. as a settler colonial state built on and by chattel slavery. However, the need to consider transnational contexts is also acknowledged in chapter 10 of Patricia Hill Collins' seminal work Black *Feminist Thought: Knowledge, Consciousness and the Politics of Empowerment*, citing Black American and Black British feminist theorizations of the "intersecting oppressions of race, class, gender, and sexuality" (p. 228) as universal concepts within the global matrix of domination, noting, however, that the ways domination is structured in various nation-states differs. Arguing for the utility of incorporating more non-U.S. Black feminist perspectives into Black feminist theorizing, Hill Collins notes that

> shifting to a global analysis, not only reveals new dimensions of U.S. Black women's experiences in the particular matrix of domination that characterizes U.S. society, but it also illuminates how a transnational matrix of domination presents certain challenges for women of African descent.

(p. 231)

This particular sentiment has been critiqued by Black feminists, such as Yaba Blay (2008), who points out the ways Hill Collins inadvertently centers U.S. Black feminist perspectives by highlighting the ways global analyses may yield deeper insight into U.S. Black women's experiences. She further critiques the assumption of a universal gendered experience or gender-based oppression and that despite Hill Collins' urging to "center U.S. Black women without privileging their experiences" (Hill Collins p. 228), it is "through U.S. Black feminist eyes that we would have to witness what constitutes 'exploitation' everywhere"

(Blay, 2008, p. 63). Thus, despite Hill Collins' call to consider the role of the U.S. nation-state as a unit of analysis, particularly in its production of dominant tropes about U.S. Black women and her argument that transnational consider-ations enrich Black feminism, her argument provides a narrow lens of what these engagements may look like and – 31 years after the publication of *Black Feminist Thought* remains rich with opportunities for Black Feminist engagements. I argue that particularly from a methodological standpoint, some of these engagements can and should be addressed by allowing some of the questions raised by trans-national and postcolonial feminist theories and practices to guide our research engagements. For instance, Alexander and Mohanty (1997) ask us to consider the following questions, among others:

> What kind of racialized, gendered selves get produced at the conjuncture of the transnational and the postcolonial? Are there selves which are formed outside of the hegemonic heterosexual contract that defy dominant (Western) understandings of identity construction? . . . What kinds of transformative practices are needed in order to develop non hegemonic selves?
>
> (p. xviii)

Asking these questions and others, then, enables us to theorize and analyze feminist praxis in global contexts, which, according to Alexander and Mohanty "involve[s] shifting the unit of analysis from local, regional, and national culture to relations and processes across cultures" (xix). Qualitative researchers invested in these ideas, then, could consider the ways these relations and processes across cultures manifest, as well as the role of capitalism, coloniality, and race in their inquiry. Of course, Transnational feminism and Black feminism are two rich bod-ies of feminist scholarship that cannot be brought into conversation without tend-ing to their histories and nuances. In more recent years, scholars have worked to do so, acknowledging the complementary tenets of both paradigms. Tracing the emergence of discourses surrounding transnationalism and intersectionality as a Black feminist concept specifically, Jennifer Nash notes that "women's studies has long rehearsed a story about itself that presumes that intersectionality and trans-nationalism are wholly separate analytics, each embodied by a particular racially marked subject" (p. 83). The racially marked subjects, Nash refers to, then, are South East Asian women scholars and activists, who pushed transnational theo-ries to the fore in the 1990s, and Black U.S. women scholars, such as Kimberlé Crenshaw, who coined and further developed intersectionality theory. The issue with this, as Nash points out, is that the dominant story that positions two frame-works as separate analytics used in the field of women studies to address a need for both critique and inclusion, as well as frameworks that require scholars who seek to advance theory and practice, are being positioned to compete for the small amount of available resources for women of color.

At the end, Nash asks us what it might mean for "black feminism to insist on telling other stories about intersectionality, stories that suture intersectionality to transnationalism" (p, 104). Nash's intervention is an important one for moving

both Black feminism and transnational feminism forward. In particular, she notes that reading both analytics together allows us to rethink about the central transnational feminist notion of "coalition building" to work toward not only intimacies among women of color, but also "intimacies between analytics that have been wedged apart" (Nash, 2018, p. 106).

Heeding Nash's call to thinking of Black feminism and transnational feminism alongside each other, scholars such as Melchor Hall and Cynthia Dillard have been working toward a theoretical framing that engages elements from both theoretical frameworks by engaging in this process of suturing.

Recent articulations of transnational Black feminist scholarship (Okpalaoka & Dillard, 2012; Hall, 2019; Burkhard, 2019) point to the need of engaging Black Feminist Frameworks that attend to the global and transnational dimensions of Black women's lives and lived experiences. A transnational Black Feminist approach to qualitative research marries Black feminist practice and transnational feminism in order to produce a methodological and theoretical lens that both attends to the particular lived experience of Black women, as well as considerations of colonization and the pursuit of anti-colonial practices throughout the conceptualization, implementation, and presentation of research. Any such work, however, is required not only to contend with the genealogies of the feminist scholarship from which these ideas emerge, but also work to de-essentialize hegemonic ideas about Blackness and womanhood, and Black womanhood. Describing Black feminism as "a critical social theory born out of the live experiences of Black women . . ., Venus Evans-Winters (2019) notes that "Black feminism is a tradition of Black women's intellectual thought is devalued and marginalized in qualitative methods courses and textbooks" (p. 17).

In this way, this book offers a further intervention of texts that value and critically contextualizes Black women's ways of knowing by placing them front and center in the qualitative research process. Furthermore, a transnational Black feminist approach additionally offers an intervention in the oftentimes U.S.-centric ways of understanding Black women's lived experiences. Rather than placing U.S. Black women's histories and experiences in contrast or contention with those of Black transnational and immigrant women, it is my hope to use the stories, poetics, and knowledges of Black women born outside of the United States to build and develop intimacies (Nash, 2018), among Black women across difference. This development of intimacies, I argue, requires an engagement of each others' stories and experiences marked by careful listening and an ethic of care (Larrabee, 2016).

Hall (2016, 2019) proposes four guiding principles of Transnational Black Feminism (TBF) in International Relations: (1) intersectionality, (2) solidarity, (3) scholar-activism, and (4) attention to borders/boundaries. Hall's outstanding work provides a roadmap for engaging both analytics in the field of International Relations. Drawing on Evans-Winter's (2019) work, I expanded Hall's framework by including the important Black feminist tenets of daughtering and (other) mothering, and propose "granddaughtering" not only as a way to think about the multi-generational implications of Black feminist knowledge production, but also as a means to trace raced, classed, and gendered stories and their implications

across time. In addition to Hall's (2019) proposed tenets of solidarity and scholar-activism, I propose considerations of these concepts specifically under consideration of qualitative research design and methodologies. Finally, drawing from transnational feminist praxis, I propose the interrogation of the legacies of colonialism alongside the need to attend to borders and bounders (both metaphorical and physical) in the development of a Transnational Black Feminist methodological approach. This notion is of importance not only considering the structures of settler colonialism in the United States and Canada, but also considering that many Black immigrants hail from prior colonies. To clarify the ways these concepts are taken up, I will provide a brief overview of each.

Intersectionality

Intersectionality is the understanding that identities are multiplicative, complex, and never limited to just one identity marker such as race, class, gender, or sexual identity. On the basis of these multiple identity markers, individuals may experience oppression in certain contexts and benefit from privilege in others. Legal scholar Kimberlé Crenshaw played an important role in the development of intersectionality, which has since been employed in a number of disciplines and contexts. In *Mapping the Margins* (1991), Crenshaw discusses the ways in which Black women were erased from discussions about race-based oppression, which centered Black men, as well as gender-based oppression, which centered white women. Attempts to protect Black men from getting stereotyped in the context of domestic violence erased the victimization of Black women as affected by domestic violence.

Delgado and Stefancic (2001) define intersectionality as "the examination of race, sex, class, national origin, and sexual orientation and how their combinations play out in various settings" (p. 51). It should be noted here that most intersectionality scholars reject an additive model of how these factors interact, and, instead, they prefer a model that shows the ways in which these factors interact in a matrix of oppression (Collins, 1990). The notion of intersectionality helps to frame and understand the multiplicative nature of identities and allows for the examination of identities at the intersection of race, class, gender, ability, and nationality.

By explaining oppression as a multilayered experience, Hill Collins (1990) coined the term matrix of domination in *Black Feminist Thought: Knowledge, Consciousness and Politics of Empowerment*. Opposing additive models and those that analyze oppression due to class, race, gender, or social status independently of one another, Collins (2010) points out: "The significance of seeing race, class, and gender as interlocking systems of oppression is that such an approach that fosters a paradigmatic shift of thinking inclusively about other oppressions, such as age, sexual orientation, religion, and ethnicity" (p. 415). Thus, intersectionality may offer both individual and systemic analyses of oppression and lived experience. However, taking a transnational stance means that we must consider the ways these systems translate or do not translate from place to place, meaning

that raced, classed, or gendered or migrant identities and the solidarities or divest-ments that rise to the fore after one immigrates may not have been important to an individual before migrating. Migration scholar Floya Anthias (2008) employs the concept of "translocational positionality" to complicate the ways intersectionality has been applied to migration research. She argues that this application has often-times constructed people as members of "fixed and permanent groups" (p. 14) with respect to ethnicity, gender, and class, rather than the social processes and structures that produce these groups in any given context. Employing a transloca-tional lens of studying migrant's experiences, then, allows for the understanding that they are not bound to one location or positionality but, rather, that belonging and identification are both contextual and situated.

An intersectional approach typically requires us to consider questions to the role of race, gender, class, and other aspects in our research. However, taking a transnational perspective in working with (im)migrant communities also beckons us to consider the following questions (among many others):

- What are the processes of racialization and racial formations in participants' regions of origin?
- What were the gendered experiences of participants before, during, and after migration? How do they understand their gendered identities now?
- What are the class structures in participants' regions of origin, and how, if at all, do they translate to their current class status or experience?

(Other)Mothering, Daughtering, Granddaughtering

Patricia Hill Collins (1987) notes that Black families have always included other mothers (women who support blood mothers in their mothering responsibilities), extended family, and kinship networks, as well as fictive kin. Everet alt, Marks, and Clarke-Mitchell (2016) note that "this network of relationships was neces-sary for the survival of the Black family and also speaks to the roots of African descendants in the Diaspora" (p. 336). As Black feminist and womanist scholars have pointed out, other-mothering is also an important aspect of Black women in the academy, who create spaces for Black women students and fellow scholars to thrive. Venus Evans-Winters (2019) posts that we must not only consider the role of Black mothering, but also attend to the role of daughtering, which she defines as "a worldview that shapes your state of mind, and [a] way of being and navigat-ing the social world" and "a process or identity that is not necessarily genetic, but spiritual, and the spiritual affects the physical, behavioral, corporeal, and cerebral. Daughtering reminds you that you are never alone in the world" (pp. 137/138). Considering this form of being in the world, as "somebody's daughter" allows us not only to understand our interconnection with the world around us, but also carries with it the responsibility and accountability for our actions, specifically to those who care about us and claim us as members of their community and those who came before us. However, there is also a way in which the stories, cautionary tales, and ways of knowing passed on to us by other mothers, other mothers, and grandmothers shape our own understanding of the world. As we move through

generations, some of our grandmothers' and great-grandmother's ways of know-ing become less accessible to us, with only fragments of their lives passed down or mediated through others. However, oftentimes it is their lessons and knowl-edges that have shaped our own raced, classed, and gendered experiences in ways that may be unbeknownst to us. For instance my own grandmother's travels from Jamaica to Canada for the pursuit of financial stability not only served as a frame-work for many of her children and grandchildren to envision their own trajecto-ries, but is also evidence of the ways of the various forms in which hegemonies shape-shift, as the economic exploitation of the global South continues to contrib-ute to push and pull people to migrate to the North for economic survival. While my own mother migrated for love, her migration was also always framed as being a potential educational and economic benefit, which she has leveraged to lend financial support to family members who remained in the Caribbean. Considering the implications of (other)mothering, daughtering, and granddaughtering, we may consider the following questions:

• What does (other)mothering, daughtering, and granddaughtering mean to our research practice and/or the way we navigate research with communities?
• What stories, ways of knowing, and spiritual practices inform our under-standing of what we know?

Solidarity and scholar activism

Solidarity and (scholar) activism can be complicated, yet crucial notions for the implementation of qualitative research projects rooted framework that takes up both transnational and Black feminisms. Dai (2016) highlights the importance of solidarity from the epistemological perspective and the political perspective. The epistemological perspective reckons with the idea that women experience gender-based oppression differently (and the category "woman" itself is not a uni-versal category attached to the same lived experiences) and therefore requires an intentional, political coming together of women to address gender-based oppres-sion and patriarchy at the macro-level. From the political perspective, solidarity is an important means to resisting structural patriarchal oppression. However, historically, tensions have arisen around the power dynamics that structure or are contained within solidarity-based approaches, particularly the notion of the Western notion of a "global sisterhood" (Chowdhury, 2006) that often obfuscates difference and reinscribes white feminist ideologies. For qualitative research-ers deploying a Transnational Black Feminist Framework, the question of what this may look like in praxis arises. Hall (2019) notes that solidarity-building in diverse communities is a central aspect of being a scholar activist, and that we must use our scholarly voices to name those of our struggles that are tied to the struggles of others. Of course, this may look very differently for each researcher, research project, and community. However, Basarudin and Battacharya (2016) provide guidance in this endeavor, noting that we must attend to the "implica-tions of inequalities and differences" (p. 44) as we engage with our interlocutors

or participants, who allow us intimate glimpses into their lives. Thus, we may ask the following questions related to solidarity building and scholar-activism of ourselves and our research:

• What may the enactment of solidarity and scholar activism look like for me and my participants?
• What are my assumptions about the shared experiences and differences my participants and I hold?
• In what ways are my own struggles tied to those of my participants, and how can I name these struggles?

Interrogating the nation, borders, and coloniality in qualitative research processes

Proposing the notion of "methodological transnationalism," Amelina and Faist (2013) argue that transnational approaches should refrain from centering the nation-state for empirical analysis in order to move away from "methodological nationalism (Wimmer & Glick Schiller, 2002) that assumes nation-states as natural entities." As a nation-state, the United States, for example significantly shapes the experiences and narratives of the Black immigrant women who participated in the study. After all, it is the U.S. government that determines who is allowed in this space in the first place (by issuing visas and green cards) and who will be subject to expulsion.

Rather, approaches rooted in methodological transnationalism require a consideration of multi-sited research endeavors, which must be self-reflexive, and consider the particularities of space and mobility, particularly with respect to the dichotomization and categorization of participant groups, and attention to the larger contexts that impact migration.

Conducting qualitative research in a settler colonial space such as the United States and seeking to employ methodologies that interrogate, reject, or counter colonial practices require a number of theoretical, methodological, and epistemological considerations. For one, it requires consideration of the complexities of the (settler) colonial encounter, especially since decolonization has different goals based on the context of the colonized space. Tuck and Yang (2012) discuss these goals by first distinguishing between external colonialism and internal colonialism. External colonialism requires the seizing of foreign land and peoples for military purposes, the creation of borders, and the exploitation of natural resources, including people. Internal colonialism, on the other hand, focuses on the colonial efforts within the imperial nation, including modes of control that ensure the security and success of the nation. Settler colonialism, then, has both external and internal characteristics, since the colonizer, or settler, is present in the same space as the colonized.

Thus, in a settler colonial space, anyone who is not Indigenous, even if they were brought to that space or ended up there due to the effects of external colonialism in their own countries, can be deemed a settler. Settler colonialism, then,

works both internally (by erasing Indigenous peoples, appropriating and exploiting land, etc.) and externally (neo-colonial, militarized efforts of the nation-state to secure foreign resources). Tuck and Yang (2012) thus invite us to critically engage the term "decolonization," as it has been frequently used as a metaphor in recent educational discourses. They note that scholars often "make no mention of Indigenous peoples, our/their struggles for the recognition of our/their sovereignty, or the contributions of Indigenous intellectuals and activists to theories and frameworks of decolonization" (pp. 2–3). Decolonization as a term, then, is often used in ways that are divorced from those who developed it (Indigenous peoples) and employed simply as being synonymous with anti-racist or anti- oppressive scholarly pursuits.

The effort of pursuing decolonization on the part of non-Indigenous people, then, requires thoughtful action and responsibility, particularly for people of color who are required to reckon with their position within the colonial relations that have produced natives, settlers, and slaves. Hence, anyone who enters a settler colonial space, such as the United States, is implicated as either a settler (by buying into the modes of the nation- state and whiteness) or as a criminalized intruder by remaining undocumented (Tuck & Yang, 2012).

Conversely, Dei (2006) notes that the very effort of "decolonization" invokes a notion of colonialism as a past grievance that is now sought to be undone. He uses the term "anti-colonial" to denote the kind of theorizing and research practice that rejects colonial practices and engages the situated knowledges of colonized subjects without imposing a Eurocentric lens onto their knowledges. Therefore, exploring the best ways to represent the voices and knowledges of people whose lives continue to be impacted by the historical and contemporary implications of imperialism should be a central part of decolonizing and anti-colonial approaches to qualitative research.

Anti-colonial and women of color feminist approaches to qualitative research (Carlson, 2016; Patterson, 2013) must inadvertently aim to consider both empire and Indigeneity, as well as the geopolitical and socio-historical contexts that have shaped contemporary spaces of knowledge production, such as curricula, educational policies, and the ways educational institutions operate. What also must be considered, however, is the knowledge production that emerges from the absence or presence and visibility or invisibility of bodies of color in predominately white spaces and institutions.

Although this circumstance is highly contextual, it is very much shaped by chattel slavery, European imperialism, and migratory flows that were shaped by the latter.

At the end, an anti-colonial or decolonial methodology requires the engagement of the complexities outlined by Tuck and Yang (2012), particularly with respect to the scenarios that render immigrants and those with transnational engagements either as settlers or as criminalized subjects. For this study – whose goal is to center the experiences of Black transnational women with consideration of the contexts of European colonialism and White Supremacy that shape them – the methodological implications are primarily rooted in the acknowledgment of the specific

context that renders us temporary or permanent settlers, colonized subjects, and people who are implicated in, as well as victimized by, White Supremacy.

Carlson (2016) outlines eight principles of an anti-colonial methodological frame for settlers under consideration of Indigenous, feminist, anti-racist, Critical Race Theory (CRT), and participatory action/activist research approaches: (1) resistance to and subversion of settler colonialism; (2) relational and epistemic accountability to Indigenous peoples; (3) land/place engagement and accountability; (4) egalitarian, participatory, and action-based methods; (5) reciprocity; (6) self-determination, autonomy, and accountability; (7) social location and reflexivity; and (8) wholism.

Although it may not be easy to attend to all of these principles evenly and equally well, they will drive my inquiry in terms of both its design and the analytical processes engaged. In addition to the implications of decolonial and anti-colonial methodological approaches, transnationalism also has implications for the methods employed for the study of experiences, lives, and identities that are shaped not only by the crossing of borders, but also by maintaining potential allegiances, roots, and connections in different nation-states and cultural spheres. According to Amelina and Faist (2013), transnational approaches should refrain from centering the nation-state for empirical analysis. Instead, they argue, "methodological transnationalism encompasses various research methods that correspond to current epistemological approaches to the relationship between space, the social and mobility" (Amelina & Faist, 2013, p. 2).

These approaches require a consideration of multi-sited research endeavors, which must be self-reflexive, particularly with respect to the dichotomization and categorization of participant groups and attention to the larger contexts that impact migration. Wimmer and Glick Schiller (2002) have noted that there exists "methodological nationalism" in migration studies and transnational research. They argue that researchers must refrain from positioning nation-states as natural entities; yet, they are often positioned as such. The nation-state, in this case, the United States, significantly shapes the experiences and narratives of the Black immigrant women who participated in the study. After all, it is the U.S. government that determines who is allowed in this space in the first place (by issuing visas and green cards) and which consequences face those who do not have them.

One final concept that has proven itself to be particularly useful for this study is the notion of "methodological cosmopolitanism" (Glick Schiller, Darieva, & Gruner-Domic, 2011). This approach employs a "both/and" approach with respect to the identities of transnational research participants and seeks to move beyond the strict distinctions of "the global/local and national/international spatial levels" (Amelina & Faist, 2013). Thus, it creates a space for multiple perspectives with respect to the participants that can affect and be linked to all of the aforementioned spatial levels simultaneously.

Amelina and Faist (2013) note that an approach rooted in methodological cosmopolitanism allows us to consider multiple ways of belonging, for example, in terms of religion, politics, or social circles, or how they relate to multiple locations. Spatiality, according to this approach, then, is not a blank slate that is simply

affected by social contexts; rather, it regards space as a relational construct that is dependent on histories, material artifacts, and social contexts. Amelina and Faist (2013) argue that based on this approach, "researchers profit if they do not pre-define the existing territorial container, but study actors' strategies of space formation and space appropriation" (p. 8). While this may be beneficial to some researchers who study migration, or social geography, this notion conflicts with the principles of an anti-colonial approach, which requires us to keep at the forefront that the land we are on (if in the United States) is stolen land that brings responsibilities with it to be considered. However, the notion that participants maintain and develop identities that shift depending on context, or exist at the same time (e.g. Black, Muslim, woman) and require us to consider different meanings, is particularly useful for the Transnational Black Feminist approach to qualitative research, particularly as we may interrogate what these identities mean to ourselves, our participants, and the ways they fit or do not fit into dominant discourses.

Diversi & Moreira (2009) notes that Gloria Anzaldúa's work taught him that his body poses a threat in the U.S. academy because he does "not fit." He argues, "her theory brings the body into place . . . the body that does not fit . . . does not fall in the binaries of colonization . . . It's the story of the body told through the body" (p. 22). Anzaldúa theorizes the "betweenness" of bodies that do not fit, bodies that do not reflect normative ways of being but "Otherness" (of color, queer, disabled, etc.). Those who lead lives across multiple spaces, locations, nation-states, languages, and identities, which at times requires that their identities or identity markers take on different meanings. The chapters that follow introduce a group of women whose experiences, in many ways, are theory in the flesh (Hurtado, 2003).

Note

1 For the purposes of the study centered in this book, it is not my goal to impose pre-existing notions of what constitutes Blackness or Black identity onto the participants or the data. However, since my work is centered on Black transnational women, I draw on the context of the United States and the definitions I can find within this context for the purposes of sampling. Therefore, it is my goal to select participants not only who self-identify as Black, but also those who identify as Black for the purposes of the U.S. census.

2 Excavating multiple contexts

In 1922, Bronislaw Malinowski published the ethnographic monograph *The Sexual Life of Savages in North-Western Melanesia*. Both the book and its predecessor were based on Malinowski's observations of the Melanesian people on the island of New Guinea. Although it had been translated in four languages and received positive reviews at the time of its publication, Malinowski (2013) described it as a failure, noting that he wanted his work to be "regarded as an achievement in fieldwork and in methods of exposition (p. xx)" bemoaning that it had not received the attention he believed it deserved.

When chapters of his work were assigned to me in a methodology course in graduate school, more than 80 years after its publication, the instructor asked me to swallow my resistance to the language and allow Malinowski to instruct me. I read the depictions of his travel to New Guinea, his arrival in the village in the north of the island, as well as the observations he made of the people who lived there – his occasional fatigue with their foreign ways, foreign language, and foreign foods. I tried to make sense of the way he described their love, mythology, parenting, and the organization of their social world, and the judgments he made based on these ideas. I swallowed hard at each recurrence of the word "primitive" and "savage," which, the professor of the class told me, was not to be a "deterrent." After all, we should measure the language by the yardstick of its time. I breathed through the conclusions Malinowski presented as the only viable capital T – Truth, because he, a learned European anthropologist, had drawn them. The people on the island going about their day were his subjects, and he was the observer who was trying to make sense of their ways. Malinowski's depictions grabbed the rose-colored glasses off my face and filled me with the urge to leave behind a field whose origins felt in opposition to what I wanted my work to do. Somehow, all of my other research methods courses had managed to gloss over the early ideologies and goals of ethnographic and subsequently qualitative research. Finally, I was glad to read his admissions in the foreword of the third edition of his work that although he still regarded the Melanesians as "primitive," "ignorant" people, he challenged himself and other ethnographers to acknowledge that

> in the future we should have neither affirmations nor denials, in any empty
> wholesale verbal fashion", but instead full concrete descriptions of what they

DOI: 10.4324/9781003056621-3

know, how they interpret it, and how it is all connected with their conduct and their institutions.

<div align="right">

(1932, p. xxviii)

</div>

As much as I was antagonized and agitated by his writing and felt tempted to dismiss it, Malinowski's call to researchers forced me to question my own practices and orientations as an emerging researcher. It was during this time of questioning that I encountered Chrisette.

Winter

> *Entering the field:* Imagine *yourself then, making your first entry into the village, alone or in company with your white cicerone. Some natives flock round you, especially if they smell tobacco. Others, the more dignified and elderly, remain seated where they are.*
>
> *(Argonauts of the Western Pacific, pp. 13–15).*

Chrisette and I walked past each other in the cold hallway of our apartment building in the winter of 2016. We smiled at each other, like the strangers we were. "I love your coat," she said in passing, and I responded, "thank you! I love yours, too." Ours was a true Midwestern winter banter. Before I was able to turn to walk away, she started to talk, and I started to listen. She didn't stop talking until she finished her story of coming to Ohio from Haiti, of the violence she experienced there because of her political work in journalism, the death of her newborn baby due to a heart defect, and her feelings of being all on her own in this country. Regarding my pregnant belly, she cautioned me: "Let nothing stress you out. Stress will kill you, and it will kill your baby. My baby passed away, because I had been so stressed during my pregnancy, trying to escape the political gangs in Haiti." We left each other with small strips of paper with our phone numbers on them. I had no intention of reaching out to her because despite her advice regarding stress, the stories she shared with me in the short amount of time left me unsettled. As a graduate student, I felt stressed enough.

Spring

> *Proper conditions for ethnographic work. These, as said, consist mainly in cutting oneself off from the company of other white men, and remaining in as close contact with the natives as possible, which really can only be achieved by camping right in their villages (see Plates I and II). It is very nice to have a base in a white man's compound for the stores, and to know there is a refuge there in times of sickness and surfeit of native.*
>
> *(Argonauts of the Western Pacific, p. 15).*

One month later, we ran into each other again. This time, her mood seemed brighter, as she told me: "I was hoping to run into you. I had a dream about your

grandmother. She says your ancestors are taking care of you." The conversation spooked me so much that I called my mother, who tells me to stay away from this woman. "You never know what they're after," my mother tells me. I don't have to ask her whom she is referring to with "they." As the daughter of a Jamaican woman, I am aware of the ways colonization has strained the kinship between Haiti and Jamaica, as well as global representations of Haiti which are focused on the poverty, and the iron-hold NGOs took on the island after the devastating earthquake of 2010. But more importantly, I am familiar with the blurred lines between myth and magic, and death and life in the Caribbean. That day, I began jotting down notes about Chrisette and my interactions. Although I did not have the intention of asking her to participate in my research, I was intrigued by the memories and emotions her stories stirred in me, as well as her lived experience as a woman and mother who had overstayed her visa and tried to navigate and survive the same city, the same neighborhood, the same building I lived in. Somehow, our lives had become intertwined, and the identities visa-holder/visa-overstayer, mother-of-four/pregnant graduate student, member of a Haitian church community/isolated graduate student, Haitian/Jamaican, and German, started to on different meanings vis-a-vis each other.

> *But the Ethnographer has not only to spread his nets in the right place, and wait for what will fall into them. He must be an active huntsman, and drive his quarry into them and follow it up to its most inaccessible lairs. And that leads us to the more active methods of pursuing ethnographic evidence. It has been mentioned at the end of Division III that the Ethnographer has to be inspired by the knowledge of the most modern results of scientific study, by its principles and aims*
>
> *(Argonauts of the Western Pacific, p. 16).*

One day, Chrisette knocked on my door early in the morning. When I opened, she dragged baskets and boxes with baby products, a bassinette, a bathtub, and diapers into my apartment. I was rendered speechless by her kindness, as well as the knowledge that she cleaned rooms at the hotel down the street for 3 dollars per hour and often struggled to buy groceries. "That's nothing," she tells me. "My church community got it for me and I am giving it all to your baby." I was not only amazed by this community to which she had access but also moved that she would give me these items, which had been intended for the baby she talked about so often – the one who died at the hospital. Holding a tiny hat, she told me how she had given birth in a church member's car, because she couldn't make it to the hospital in time. Then, when she was sick after giving birth, the nurses and doctors spoke to her harshly. "I was so cold and the nurses didn't care at all," she told me. "They spoke so loudly, and acted as if I was dirty. It must be because of my English," she observed.

Summer

> *The scientific treatment differs from that of good common sense, first in that a student will extend the completeness and minuteness of survey much further and*

> *in a pedantically systematic and methodical manner; and secondly, in that the*
> *scientifically trained mind, will push the inquiry along really relevant lines, and*
> *towards aims possessing real importance*
> *(Argonauts of the Western Pacific, p. 18)*

On some days, Chrisette and I bonded over our shared experiences as immigrant women; on others, the difference between our experiences in the United States became so glaring that it eclipsed everything else. For instance Chrisette had heard from someone at her church that a few places were hiring people without work authorizations. She had been working as a maid at multiple hotels, but this work proved to be unstable and back-breaking. When she asked for a ride, I heaved my 9-month pregnant body behind my hot steering wheel and drove Chrisette across town. However, we noticed after about 45 minutes that the address was incorrect (in Columbus, Ohio, there is a difference of many miles between South High Street and North High Street), and we drove around aimlessly in search of the job center. At the end, 2 hours and several Google searches later, I found the correct address. When we entered the air-conditioned building, I was on the verge of passing out from the heat outside. Chrisette grabbed an intake form and gave it to me to fill out on her behalf. The first question on the form required a social security number and/or proof of work authorization. "Can't we just put any number down?" She asked, when I relayed this information to her. Seeing the desperation in her face, and her 2-year-old, who had gotten comfortable on one of the chairs, I exhaled my annoyance at the wasted day.

Autumn

> *In fact, as they knew that I would thrust my nose into everything, even where a*
> *well-mannered native would not dream of intruding, they finished by regarding me*
> *as part and parcel of their life, a necessary evil or nuisance, mitigated by dona-*
> *tions of tobacco.*

In June, only a few weeks after my daughter was born, Chrisette excitedly told me that she had landed an interview in yet another hotel and asked if I could watch her daughter. At this time, I was juggling a baby and working from home to make money, since I was not getting paid over the summer. Looking at my newborn and my laptop, I told her over the phone that I simply could not take on another task. Instead of a response, there was a knock on the door. She pushed the little girl in and left. "I'll be back in an hour. Maybe two." The little girl immediately sprinted toward the bassinette and tried to climb in next to the newborn, who woke up screaming and startled. I spent the next 4 hours trying to figure out how to keep both children happy. While I was changing the baby's diaper in the other room, I could hear the little girl's voice, crisp and beautiful, singing a hymn in Kreyol. When her mother picked her up, she shared the good news: she had found work again. It was only a few days later that she sent me a text message that read

"Hurricane Matthew has destroyed everything at home. My mother's house is gone." When I call her, she tells me her head hurts so much from crying. I cry, too, and ask how I can support her. She tells me: "I need you to tell my story, I mean write it down." She brought a stack of paperwork and explained that the organization that agreed to support her asylum case needed the story of why and how she came to the United States – in written form. At that point, I had heard bits and pieces of the story many times both in English and French. Then, in the office of the immigration support organization's support staff, the staff member alternated between listening, taking notes, and interrupting her to clarify dates, places, names, and other types of verifiable information. The last time I heard the story, she was asked to tell it to a third staff member to add details she had never before included, which were deemed necessary to make her case believable, her trauma verifiable and real enough to be considered for asylum. At the end, she provided me with documents that included tables and checklists to meet eligibility requirements. We recorded her telling of the story in French, Kreyol, and English, based on which I crafted a written product, which I slipped under her door while she was at work. On that day, she returned with tears in her eyes. "It is exactly, no better, than I would have written it if I could have," she noted. And "I like that when I give you a job, you do it perfectly." The tears dried, and hope crept into our hearts. After submitting Chrisette's paperwork, months crawled by and nothing happened. She told me that she no longer had the strength to pursue the asylum process. I wanted to encourage her to keep at it, knowing from my own experience how much patience is required when dealing with immigration agencies, but her mouth formed a straight line and she said no. I couldn't help but feel that once again, that time had been wasted.

Winter

> *The principles of method can be grouped under three main headings; first of all, naturally, the student must possess real scientific aims and know the values and criteria of modern ethnography. Second, he ought to put himself in good conditions of work, that is, in the main, to live without other White men, right among the natives. At the end, he has to apply a number of special methods of collecting, manipulating, and fixing his evidence.*

In the winter of 2017, I found Chrisette's apartment empty, her Facebook account without updates, and her phone number changed. A torn piece of paper with an address across town was taped to my door and signed C. I started to receive phone calls from strangers inquiring about her and learned this way that she had put me down as her next-of-kin and emergency contact. My mind began to construct scenarios of what might have happened to her. Had she been picked up by one of the many Immigration and Customs Enforcement vehicles? Had she decided to move in with family and abandon her life in Ohio? What had happened to her daughter? As I was packing my own apartment up to move on, I wandered over to what used to be her place. The familiar smell of plantain fried in the oil she kept

in a huge 1-gallon container under the sink had already mostly faded. As I stood there, holding the bassinette she had hauled over to my apartment, the door flew open, and three toddlers emerged, laughing and screaming, running out in front of their mother. The building had already moved on. Packing up the car, I noticed a letter in the dirt on the parking lot. It was addressed to her. I picked it up and placed it into a larger envelope bearing the address from the torn sheet of paper. I wrote a note with my number and new address on it, asking her to call me any time.

> *To pause for a moment before a quaint and singular fact; to be amused at it, and see its outward strangeness; to look at it as a curio and collect it into the museum of one's memory or into one's store of anecdotes – this attitude of mind has always been foreign and repugnant to me. Some people are unable to grasp the inner meaning and the psychological reality of all that is outwardly strange, at first sight incomprehensible, in a different culture. These people are not born to be ethnologists. It is in the love of the final synthesis, achieved by the assimilation and comprehension of all the items of a culture and still more in the love of the variety and independence of the various cultures that lies the test of the real worker in the true Science of Man.*
>
> *(Argonauts of the Western Pacific, p. 278).*

Are ethnologists born? Who are the real workers in the true Science of Man? When I brought these questions inflamed by Malinowski's words to my next ethnography class, the professor regarded me with guarded eyes. "You need to read more, Tanja," she said. Malinowski does not represent the field anymore, so much has happened since. Of course, she was right in some ways – much has happened since, but my desire stemmed from continuous reckoning with colonial histories and viewpoints, rather than a dismissal of the great work that has been done to move critical methodologies further.

It is in this effort that I turn to methodologies that were created in response to European imperialism and White Supremacy. Intentionally, I sought methodologies that explicitly aimed to humanize instead of dehumanize (Paris & Winn, 2013) – methodologies that were decolonial (Smith, 1999), anti-colonial (Dei & Kempf, 2006), and feminist. In short, I sought methodologies that would allow me to center the experiences of Black transnational women and represent their narratives while considering the contexts that shape them. Before discussing these methodologies in further detail, I will provide a foundation for this discussion by positioning myself as a researcher–participant–friend.

The following section serves two purposes: (1) to engage in a reflexive process required by the critical qualitative methodologies discussed; and (2) to clarify epistemological leanings, subjectivities, and understandings that have impacted both the methodology and the methods of this dissertation study.

By making hard choices on which stories to tell and how to tell them, I sought to avoid a further re-inscription of stereotypical tropes that add to the marginalization of Black transnational women. This inquiry was shaped not only by my existing relationships with Black transnational women, the recurring themes

in the conversations throughout our shared moments, and the changing political climate, but also my lack of access to communities other than my own prompted me to pursue my line of questioning and draw on a familiar "sample" of participants. As Clandinin and Connelly (2000) note, narrative inquirers "must 'fall in love' with their participants, yet they must also step back and see their own stories in the inquiry, the stories of the participants, as well as the larger landscape on which they all live" (p. 81).

I took this notion seriously, as I was already "in love" with my participants. I used the research process to reflect not only on the larger contexts that shape the stories we tell, but also how my own stories relate to theirs. The questions I posed were new to the participants, and responses were surprising to me as a researcher. At times, I found myself in conflict, because glaring differences between our beliefs would be illuminated; for example when Naima first repeated and then asked my opinion about anti-LGBT sentiments after having watched conservative news programs, I first recoiled.

I wanted to just listen without pushing back due to my new role as a researcher but found myself pushing back on her statements rather vigorously. I recognized that in order to be my full researcher self, I would not only seek to listen over talking, but also advocate for communities I care for if this became necessary. In these moments, I was very worried about violating that trust, or damaging my relationships, as they were and continue to be vital to me far beyond my professional life. In Table 2.1, I represent the participants, ages, countries of origin, languages, and educational backgrounds. The participants selected their own pseudonyms, unless they asked me to select a name for them. Because contextualization is necessary, I will also very briefly discuss how each region of origin was shaped by European colonialism and/or its relationships with the United States.

Ama

Ama and I met when my supervisor in the English as a Second Language program in which I was working at the time told me that somewhere at the Midwestern University at which I studied, there was another Black German whom he met during ESL testing, which is required for all international graduate students. I desperately wanted to meet her, as I was experiencing the isolation that comes from leaving everyone and everything behind and starting a new program. After our first meeting, Ama and I immediately became friends. Chatting a mixture of German and English, we were able to connect and develop a friendship that has been sustaining us until today.

Ama's parents are from Ghana and settled in Germany, where she grew up until pursuing her Master's degree and doctoral studies in the United States. An important region in West Africa, Ghana and its coasts remain a gateway to the past and present, as it was established under British colonial rule in 1874 and was a primary hub of the transatlantic slave trade. The British, French, and Germans amicably drew demarcation lines in 1889 and 1899 between the Northern Territories (which

Table 2.1 Participants at the time of the study

Pseudonym and age	National identity Citizenship	Languages	Educational level/Occupation
Ama (29)	German (citizen) Ghanaian (citizen)	English German Twi	Doctoral student in the Southwest o United States
Chrisette (32)	Haitian (citizen)	French, Haitian Creole, English	Some college in Haiti, ESL courses in United States; Does not claim employment due to visa status
Haki (37)	Kenyan (citizen)	English Swahili Kikuyu	Doctoral student in the Midwest of the United States
Maya (35)	Jamaican (citizen)	English Jamaican Patois Spanish	Master's degree in teaching; Middle school teacher in the South of the United States
Marisha (34)	Jamaican (citizen)	English Jamaican Patois Spanish	High school diploma, seeking to access college in the U.S. Works in service.
Naima (35)	Somali (American citizen)	English Somali	English as a second language (ESL) student seeking to complete general educational development (GED)
Tee (28)	German (citizen) American (citizen)	German English	Business student in the South of Germany; works in Germany and the United States

became a British protectorate) and the surrounding areas, which were colo-nized by France and Germany (Berry, 1994). Thus, Germany and parts of what is considered contemporary Ghana share a close colonial history, and according to Schmelz (2009) more than 40,000 people "with a Ghanaian migration back-ground" (p. 5) live in Germany; migration of Ghanaians to Germany increased after the country gained independence in 1957, with reasons for migration primar-ily including the pursuit of education and, most recently, climate change.

Chrisette

Chrisette and I met in the foyer of my apartment building in early 2015. She complimented me on my jacket, and when we struck up a conversation, she burst into tears and told me she had just left the hospital, where her newborn had just passed away. We exchanged numbers but did not contact each other until a few months later when she called me to say that she saw me in a dream. We have been friends until she disappeared from our neighborhood in early 2017. Chrisette was not authorized to remain in the United States since before I had met her and had overstayed a visitor's visa. In my capacity as a volunteer at an organization that provides services to immigrants, I tried to support her in initiating her refu-gee process, since she experienced politically based violence in Haiti according

to her own accounts. In Haiti, she was a journalist who worked to support her region by communicating its needs to the government. In the United States, she does what she can to survive financially. During this research project, Haiti was greatly affected by Hurricane Matthew, rendering Chrisette's mother, sister, and two young boys, who are staying with their father, temporarily displaced.

Haiti, Chrisette's place of birth, is often presented as a place of tragedy and poverty, subject to natural disasters such as a devastating earthquake in 2010 and Hurricane Matthew in 2016. According to James (1963), today's Haiti was Christopher Columbus' second stop after arriving in the New World in 1492. The Spanish who settled there within only 15 years renamed it Hispaniola and brutally decimated the Indigenous population from half a million to 60,000. Spain ceded the Western third (Saint Domingue) of Hispaniola to the French in 1697, who brought African slaves there. Offspring from white planters and African enslaved women later made up a light-skinned ruling class (Corbett, 1995). This was significant for Chrisette, whose lighter skin tone not only afforded her opportunities, such as being selected to work in media communications, but also made her the target for violence. I will discuss some of these tensions later on in the chapter.

Haki

Haki and I met in the context of our doctoral studies. One day in 2014, we struck up a conversation and realized that we lived across the street from each other. On one cold Midwestern night, Haki invited me to her home, and I walked through the knee-high snow to her apartment to chat with her and her two sons for hours. I learned that she had come to the United States while her husband pursued his doctoral studies. Since then, we have remained in close contact. Kenya was a British territory for 25 years (1895–1930), after which it became a Kenyan colony and gained independence in 1964 (Wolff, 1970). According to the Migration Policy Institute (2015), approximately 102,000 Kenyans and their children now live in the United States.

Although Kenyan emigration between 1950 and 1970 was usually temporary, and mostly for the purposes of pursuing higher education, this has changed due to the unstable conditions in the country, causing most Kenyans to remain in the United States.

Maya and Marisha

Maya and Marisha are sisters and my older cousins. I met them when I was in Jamaica to meet my mother's side of the family for the first time when I was 3 years old. Because we are relatively close in age, we never ceased to be in touch. Every other month, we wrote each other letters and sent cards containing pictures. When I would visit my family in Jamaica each summer, I would see the pictures in their rooms, stuck to the mirror, as reminders that we were apart but still close. Maya came to the United States in 2005 on a visa that allowed her to work in the service industry for 5 years. Her goal has always been to go to college. When I

first came to the United States in 2009 as an exchange student, Maya came to stay with me for a few weeks during winter break; she came back to visit again in the spring. Because visa issues did not allow her to leave the country, I have not seen her since then.

Maya's older sister Marisha, on the other hand, is a mother of two sons and graduated from a teacher's college in Jamaica. She came to the United States in 2015 and has been working as a middle-school science teacher ever since. She got recently married, and she purchased a home with her new family. Previously, she acquired higher education, which has allowed her to become upwardly mobile in ways her sister was not able to.

Christopher Columbus landed in Jamaica on May 5, 1494, and immediately met with resistance from the Indigenous inhabitants (Arawaks). Only 15 years later, the first Spanish colonists came and settled there and established the slave trade. In 1655, the British attacked the Spanish and seized the island, cultivating the sugar trade, which captured and enslaved a large number of African people. After several slave rebellions, the slave trade was finally abolished in 1808 (with freedom granted in 1838). Jamaica became independent of the British crown in 1962 (Jamaica Information Service, 2017). According to Thomas (2012), 706,000 immigrants from Jamaica reside in the United States, and they primarily settle in the states of New York, New Jersey, and Florida. As other Caribbean immigrants, most Jamaicans are mostly employed in the service sector and sales force.

Naima

Naima is a mother of three and expecting her first child. She has been working on her GED since I met her in 2014. Since then, we have become quite close. It was my experience with her, a Black woman and Sunni Muslim from Somalia, which inspired this study. Since we met in the lobby of the community college she was attending in the Summer of 2014, she has drawn on me as a resource for tutoring (for which she paid me in food and sometimes money), but most of our interactions were about handling issues of daily life, including anything from purchasing make-up products in a retail store from which she never received adequate service before I accompanied her (according to her own account), setting up credit cards, and making appointments that can be facilitated by an "American"-sounding voice. At times, I have grown fatigued by her requests, which usually came in the form of stacks of paperwork to fill out, phone calls to make, or research to do online, even when our primary purpose is tutoring.

However, I have generally been very happy to support her in any way possible.

I selected Naima as a focal participant for two reasons: for one, our frequent interactions have produced a wealth of data from which I can draw. Second, some of the experiences we shared were crucial in my understanding of the intersections of citizenship, religion, race, and gender. Naima told me that because of the civil unrest in the Somalia of her childhood, she did not have an access to formal education until she came to the United States at age 21. Indeed, Somalia has had a complicated colonial history, with Italy and Britain as its primary colonizers

(Njoku, 2013). The decades of domestic unrest and the most recent flares of extremist attacks conducted by the militant jihadist group Al-Shabbab have contributed to the "migration crisis," which have rendered many Somalis as refugees in a variety of countries (Abu Sa'da & Bianchi, 2014), including the United States.

Tee

In 2008, I met Tee in my home town in Germany while she was working in the hair salon I frequented. She was the only other Black/biracial woman I had met in my hometown since my childhood. We tried to reconstruct our first encounter but could not quite remember how we started our friendship. However, we have been friends since then. Tee still lives in Germany but had moved to Bavaria. After we met, she told me she had become motivated to return to school and finish coursework that would allow her access to a technical college. She is now in her B.A. program in Business Administration and spends several months of the year in the United States. In our interview, Tee has shared with me her truly transnational history, as she has lived in both Germany and the United States her entire life. Her father was stationed in Germany in the 1980s and met her mother during this time; the couple got married and had Tee, their only child together. After her parents' divorce, her father kidnapped her and brought her back to the United States, where she started her schooling.[12]

According to Höhn and Klimke (2010), roughly 250,000 American troops and their dependents (also roughly 250,000) and tens of thousands of American civilians, who were employed with the U.S. Department of Defense residing in Germany (primarily the South and Southwest), were deployed in Germany during the Cold War. Although this number significantly decreased under the Obama administration, a number of military bases remain fixtures in the German communities of the South and Southwest and significantly impact the local cultures.

Relationships and language

Language not only plays a crucial role in this project, but also plays an important role in the depth and range of the relationships I maintain with each of the women. As a speaker of German and English, with a B.A. in Translation, who studied French for roughly 10 years, and the daughter of a woman who speaks Jamaican Patois, I was able to navigate some of the complexities related to language that emerged in the interview process – however, of course, not all. For instance whenever Chrisette became animated in our conversations, she would switch rapidly between linguistic varieties, which caused me to play "catch-up" with her meaning-making process. At the same time, I had planned to conduct my interviews in English only with Ama and Tee but ended up speaking in German with them only, because in many ways, our relationships are constructed around our shared linguistic background. This does not mean that we never speak or message in English, but that intimate or serious conversations are usually conducted in the language we share. Working with the multiple languages in my dataset meant

that I had to translate what I wanted to include. I also recognize that my lack of knowledge of Somali, Kikuyu, and Haitian Creole meant what I was able to learn from Naima, Haki, and Chrisette was quite different from what I learned from the other participants. Nonetheless, with the data I collected, I have taken on the role of narrator and mediator among the interviews, text messages, written letters, etc., and the written products that will be highlighted in the next chapters.

With regard to interview data, Dunbar, Rodriguez, and Parker (2001) note that "the interview process and the interpretation of interview material must take into account how social and historical factors especially those associated with race mediate both the meanings of questions that are asked and how those questions are answered" (p. 2). To do so, I draw on two specific data points from two participants, Naima (born and raised in Somalia) and Chrisette (born and raised in Haiti), which illustrate not only the importance of accounting for social and historical factors related to race, but also the need for researchers, who investigate racialized individuals to take into consideration the multiple contexts, understandings, and at times contradictions that are at play for participants during the interview process, as this has implications for data analysis and representation.

3 Applying a transnational Black feminist lens

> And then I came here and I found out that it wasn't so hard, and it was even accessible. Now I'm thinking, "Why not go further?"
>
> [Marisha, Interview on educational goals]

> And this, this white woman was driving. I couldn't see her, because she was in my blind spot and she called me "N – Bitch" . . . "N – BITCH" . . . I think it's from that time I started feeling. Oh my goodness, I think I'm Black.
>
> [Haki, Interview]

> One day, I left my classroom. I basically just walked out and stood outside just to breathe, when the students were so mean and racist, and I was like, I don't know anything about race, you know about racism.
>
> [Marisha, Interview]

> Also sind das net[1] nur Sachen, die ich erlebe, sondern das ist einfach universal?[2]
> *So I'm not the only one, who experiences these things, but they're universal?*
>
> [Tee, Interview]

Each of the aforementioned data excerpts describes experiences made by Marisha, Haki, and Tee. Like the other four participants (Maya, Chrisette, Naima, and Ama), they shared with me the range of experiences that marks the lives of Black women born outside of the United States, as they navigate multiple identities and spaces, sometimes at the same time. For example Naima holds American citizenship but continues to see Somalia as her home and hopes to return in the future she is envisioning for herself after pursuing education, establishing a career and providing her children, one of whom is disabled, with access to proper healthcare and education and safety. As for all of the other participants, living in America comes at a price that is often steep. The stories often emerged during interviews and unscheduled conversations with little-to-no prompting. Although the women who participated in this project hailed from different regions and continents and have experienced a variety of socioeconomic backgrounds, educational levels, religious beliefs, and world-views, much can be learned about the processes of racialization and the legacies of colonialism by examining and reading alongside each of the women's stories.

DOI: 10.4324/9781003056621-4

As indicated in the opening quotes, Tee, who was born and raised less than 30 minutes away from where I was raised in Germany, asked me about the experience of micro-aggressions during our interview, as she wondered "So I'm not the only one who experiences these things?" I was reminded that despite our vast differences in religion, upbringing, and socioeconomic status, Black transnational women have no ways to escape experiences that are rooted in racism and misogyny specific to the U.S. context. However, despite the systems of oppression we face, many of us continue to pursue education and careers to give back to our home communities and raise our children in ways that both can honor our cultures of origin as well as the spaces we navigate now.

Before delving into the narratives of three participants, Chrisette, Naima, and Tee, I will discuss some of the more coherent themes that emerged from my inquiry. The goal of presenting these themes is not to make generalizations about Black transnational women but rather to show that how the contexts of U.S. racism and narratives of the American dream are not only circulated by the women, but also reconfigured as the reality of home sets in. This part of the discussion largely includes the results from my a priori themes, which emerged from my questions about (transnational) Black women's identities, their educational and professional access and goals, including potential obstacles in the way, and the role of language in these pursuits.

While I do not seek to make generalizations, it is my goal to contextualize the narratives within the larger systems at play and understand the impacts of colonialism, racism, and misogynoir on the educational experiences and identities of the participants. The chapter is made up of three components: (1) a general discussion of the themes that emerged from the data; (2) the presentation and discussion of artifacts as part of the narratives of the focal analyzed from a transnational Black feminist perspective, and (3) poetic transcriptions (Glesne, 1997) that break up the text and bring together the voices of the participants based on themes that emerged.

Racialization, misogynoir, and colorism

In the opening paragraph, I present Haki's words, who identified the story about the white woman calling her a raced and gendered slur while she was driving as the pivotal moment in which she realized she was racialized as Black in the context of the United States. The story came up after I asked her whether her identity had changed since coming to the United States. While she did not see herself as a Black woman in Kenya, as she states, there was no need to, since almost everyone in her community was Black – it was this moment that made her identify as a Black woman. She notes, "I think it's from that time I started feeling – oh my goodness, I think I'm Black. I had not internalized it. It was not a concern to me, but I mean, there are instances where I feel like . . . oh my goodness are they doing that because I'm Black."

Haki does not see her identity as a Black woman in the United States as primarily rooted in a pan-African identity or based on shared cultural values

or traditions. Rather, it is the histories of colonialism and chattel slavery that have created a space in which a white woman driving would simultaneously draw on racialized and gendered epithets to express her displeasure with a Black woman. This is also reflected in her assertion that "she did not internalize it," "it" most likely denoting the gendered racism she experienced in this very explicit incident. Thus, Haki's emerging identity as a Black woman did not exist in this configuration before she came to the United States due to her experiences of growing up in a predominantly Black space, as she notes: "In Kenya I didn't see the need of identifying as a Black woman, because all – most of us are Black. I mean, the majority of us are Black. Like in my community, we're all Black. So there's no need of those categories. But here, now it's so different." I chose Haki's narrative about race to illuminate some of the ways racial discrimination is reconstructed through experiences that are both connected to racial categories in the country of origin and racialization in the United States, recognizing that race-based ideologies from the United States travel across the world through film and other media.

Rather than Black identity, Haki notes that social class and skin tone were defining factors that impacted her identity in her Kenyan home community, along with ethnicity. In Kenya (as in many other places across the world), lighter skin, she argues, is of importance for people who are represented in the media, such as news anchors. As a Kikuyu woman from the largest ethnic group, she says

> Kikuyu's . . . are perceived as people who are from rich backgrounds, people who hold high offices in the state, . . . it's the largest – it's the group that has produced the majority of presidents in Kenya. I don't think it matters, but people will differ with me.

Interestingly, her husband, who came in during the latter part of the interview and is not part of the same ethnic group, overheard her statement and immediately told me that many members of other ethnic groups indeed find it important, whether or not one belongs to the largest group, and that the Kikuyu indeed dominate the political landscape and hold privilege. Haki had shared with me in previous conversations that she was the first girl from her village to attend higher education and that the people from her community had rallied around and celebrated her for her success. Thus, her narrative also necessitates attention to the role of social class and upward mobility as factors that have made it possible for her not only to migrate to the United States, but to also obtain graduate-level education here.

At the end, Haki shares with me that she does not identify as African, but Kenyan, and highlights the importance of specificity. She notes that specificity is important to her particularly because she has never traveled before coming to the United States. In this, she echoes Naima's sentiments, who also tells me that she saw herself as Somali, rather than African or Black, before she came to the United States. However, while Haki continues to reject "African" as an identity, because she "prefer[s] to be specific," Naima now embraces African as an identity label in the United States. It is important to note here, that while Naima has been naturalized as a U.S. citizen, Haki remains on a nonimmigrant visa. Both Naima

and Haki express their desire of returning home to give back to their communities; this sentiment is also echoed by Maya, who is building a home in Jamaica for when she returns. Chrisette describes herself as by saying "I have light skin. I am a Black woman." [Interview]. Considering the history of Haiti, this distinction certainly makes sense, since biracial (mulatto) Haitians have historically been afforded upward educational access, social privileges, and institutional power (James, 1963).

Indeed, Chrisette tells me:

> No, in Haiti, they don't see me like Black. They see me like white girl. Yeah, even you have this color they tell you, you have money, you have to share (laughs). I have nothing. I have nothing and they're going to kill you. . . . They're always thinking they're sorry from ésclavage (*slavery*). It was like they think like
>
> • they're racist. Even you're white, they're telling 'Look at her. They take every money from the government. They're so pretty. Look at us. Us so ugly.'

> [Interview]

The aforementioned paragraph both reflects Chrisette's position in Haitian society, as well as the complexities of skin tone and social class in Haiti. A lighter skinned person, based on her assertion, is regarded with suspicion, not seen as Black, and expected to have access to financial means to share. At the same time, she did not have access to this kind of wealth as young person, nor as an adult, which positioned her in conflict to the story that was told about her or people like her. "I have my father's skin," she says. "My mother is dark-skinned." However, her ability to pursue education and a career as a journalist was tied to her skin-tone. She says "Even when you go to school. The teachers see you. If you're light, they can see your future." It was in part her skin tone that drew the attention of the manager of a radio station, who employed her when she was 17.

In Haiti, Chrisette argues, she was not rich but "able to survive" [Interview] despite her upbringing in an economically deprived area thanks to her position as a journalist and connections with the government. But this kind of visibility was a double-edged sword. Chrisette's pro-government work and efforts of seeking economic empowering for her impoverished home region also made her the target of anti-governmental violence from what she refers to as "the gangs." Chrisette left two of her children behind to escape this violence, though she was able to bring her third child to the U.S. and gave birth to her fourth child in the United States. She is convinced that the death of her baby was directly linked to the violence and related stress she experienced in Haiti. Chrisette's stories show not only the deep linkage between perceived and skin tone, but also the ways that skin tone is connected to a perceived upward mobility as "teachers can see your future." While her lighter skin tone had direct benefits to Chrisette in terms of educational opportunities, the visibility these opportunities created

opened her up to physical violence and, once in the United States, the feeling of being unable to return home without bringing harm to herself and her family.

Educational and professional aspirations

While the importance of learning and improving their English in order to achieve their educational goals was a recurring theme for Chrisette and Naima, all of the other women expressed that they felt proficient enough to pursue their educational goals, since they spoke a variety of English natively (Maya, Ama, Marisha) or had it as the language of instruction in their K-12 schooling experiences (Haki, Tee). Ama engagingly describes how her father, a Ghanaian immigrant in Germany, had always solely spoken in English with her, even though she was born and raised in Germany.

However, some of the women expressed that their home languages and varieties suffered because of their increased English proficiency or change in accent to sound more U.S.-American (as pointed out by Ama, Haki, and Maya), who said they felt their proficiency decline in the languages and linguistic varieties of their places of origin. Although the women do not all know each other, one recurring theme was the desire to pursue a career in a health care or social field.

Chrisette states that her dream is to become a nurse specialized in OB/GYN in addition to pursuing her already existing career as a journalist. Each time I saw Chrisette since we met, she has stressed that she wanted to learn English or become more proficient, particularly in grammar. In the interview, the following exchange unfolded when I asked Chrisette about her professional goals:

CHRISETTE: I don't like when I talk and like blah, blah, blah, blah, it's like some-body doesn't have education. Sometimes I want to go to the dictionary to learn new – do you understand?

TANJA: Yes!

CHRISETTE: When I talk, if I say hi, I can say it differently, like somebody who have education. I would like to say I'm education. You understand? When you go to school, you have some big difference. And when somebody sees you, you're not going to say you're educated. Somebody's going to see. She's educated. She have the good communication. She know how she can explain. She know how she can talk and then she is a good person.

Thus, the importance of English for Chrisette is not only linked to her goal of eventually becoming a nurse who specializes in gynecology, or re-entering the field of journalism, but also to how she is perceived by others. According to Chrisette, she would be perceived as a good person if she appears to be well educated and is able to express herself clearly and can communicate well. Thus, her desire to increase her vocabulary and improve her grammar (Interview) is both to change how she is perceived by people in the United States, as well as her professional goal of becoming a nurse.

Unfortunately, her status as an undocumented student made it very difficult for her to be consistent in her pursuit. Chrisette would need documentation to obtain a driver's license, which means that she has been limited to public transportation. She enrolled in a free ESL course offered by a church twice but had to quit it each time due to the difficulty of accessing class by bus. "It's too much right now," she told me with that same tight-lipped look I've come to know when I last asked about her English classes. Thus, Chrisette's dream of becoming more proficient in English and studying to be a nurse has been once again been deferred, because life is hard in the United States without documentation.

Naima wants to become a nurse to return to Somalia and help victims of the local fundamentalist attacks; Marisha wants to become a respiratory technician due to her own experiences with asthma. On the other hand, Haki, Ama, and Maya all pursue the dream of becoming professors and completing Ph.D. programs. Tee is the outlier and notes that she is not interested in pursuing a career in the social sector, as it does not offer the kind of income she envisions, which is why she is seeking to finish her bachelor's degree in business and potentially a master's degree in logistics in the future. Tee is a first-generation university student, whose first job was working in a hair salon as a stylist. Because of low wages and health-challenges in this career, she is motivated to move into fields that are more lucrative.

Six of the seven participants also expressed the wish to give back to their communities, or society, by becoming nurses or professors. In some way or fashion, they cite access to educational spaces, from GED or ESL classes, to technical and community colleges, online colleges, to Research 1 institutions as *the* pivotal factor that will advance their lives or facilitate their self-actualization. All women, except Tee, who states that she truly feels a sense of in-between-ness in terms of belonging to a country, state that they work hard on upholding their national identities. For example Chrisette notes "even if I get naturalized, I will always be a Haitian," while Maya notes about her identity upon coming here: "I saw myself as a Jamaican. And I also saw myself as a young, Black woman in Jamaica," adding "there is racial stuff everywhere." Today, she adds, she still identifies as "a Black woman from Jamaica."

Marisha, who teaches seventh grade science at a middle school in South Carolina, notes that in order to connect with her students, she has been seeking out more ways to learn about their culture, which has in turn led to a loss of her own culture, particularly in terms of accent and language, she notes. Marisha shared with me that she experienced racism from her students when she first started teaching in the United States. It was because of her students, she argues, that she had to learn how racism and race in the United States function. This understanding includes knowledge of racial profiling by the police, as Marisha notes

[N]ot to sound racist, but if a Black person here gets stopped by the police, they're more likely to get a ticket. . . . You can't help but wonder 'why does it have to be like that'? But I just learned to accept that this is how it is, and there's really nothing – I don't know if there's anything I can do to change

it, but I still stay out of harm's way. You kind of see it like you're staying out harm's way, in a sense where if you stay away from it, you won't be affected, you won't be hurt, you won't be victimized. You know what I mean?"

Thus, Marisha is aware that Black people in her area are often racially profiled by the police. However, she believes that she is able to "stay out of harms way," in order to stay safe. The idea that keeping out of harm's way ensures that "you won't be hurt" seems to connect to the killing and injury of unarmed Black people, which have been circulating the media, more so than receiving a ticket. However, Marisha's statement indicates her belief that staying out of harm's way, perhaps by not allowing oneself in situations in which one would be "victimized," seems to indicate that complying with police could protect Black people from victimization. Shortly thereafter, she interjects in our interview that she has personally experienced racial profiling while looking for a home:

MARISHA: What it has really done was open up my eyes that race is actually seen differently and so it's not – we are the same because we're all flesh and blood, but that we are really not the same because with my skin color, I'm a minority and your skin color, you're not the minority and then you really do end up start identifying with that. We're not the same and so me thinking before, we're all the same people. Now I'm thinking, well, we're not the same. I'm in the minority group and for some strange reason, started to accept that I'm in the minority group. So when something happens, so I'm in the minority group, so I don't feel bad if this doesn't happen, you know what I mean?
TANJA: Right.
MARISHA: And it's terrible because just to share something personal that just recently happened in the process of buying a house. Prior to getting the house and only to find and why I couldn't get the contract signed off on to get the house was my race. You know what that means?

Here, Marisha explains part of how her understanding has changed by being racially profiled. By accepting that she is in the minority, she accepts the racial hierarchy and context of anti-Black racism in the United States, based on which she experiences hostility (from her neighbor) and racial steering practices from realtors or "behaviors by a real estate agent vis-à-vis a client that tend to direct the client toward particular neighborhoods and/or away from others" (Galster, 1990), who tried to force her to move to an all-Black neighborhood in which the schools lacked resources and funding schools by removing other neighborhoods from their offering. It took the threat of a lawsuit on the part of a Black realtor for Marisha to be able to buy a house in the neighborhood she wanted. This practice impacts Black transnational and immigrant populations in the United States as a whole. According to Coleman-King (2014), "the integration of Black immigrants into low-income communities plagued by under-resourced, low-performing schools contributes to increased poverty levels in subsequent generations" (p. 33). Thus, even though Black transnational and immigrant families are often more upwardly

mobile than African Americans, their experiences with the U.S.-based anti-Black people impact these families, causing this upward mobility to decline in the next generation (Zhou, 1997; Vickermann, 1999).

The poetic transcription given here is an amalgamation of sentences taken from Haki, Chrisette, Marisha, and Naima. In it, I brought together what these three women shared about education in their home-countries, which, I would argue, shares similar themes of lack of access, which in some ways is gendered and in other ways deeply tied to the economic deprivation of Haiti, Kenya, and Somalia. Haki shared with me that because education in Kenya cost money, many parents decided and still decide to educate their sons rather than their daughters.

Chrisette's idea that "technology in her country sleeps" emerged during our recorded interview, while she attempted to log onto Facebook to show me pictures that related to our discussion. She sees Blackness and writing as deeply interconnected. She tells me that "In Haiti, the Black country, we had to write," as she struggles to navigate the Web browser to access her Facebook account. Thus, while education in Haiti is "asleep" when it comes to technology, Chrisette notes that academic success there requires writing by hand.

Education

Technology in my country sleeps.
They never wake up.
I don't know nothing about the Internet.
In Haiti, the Black country, we had to write –
We couldn't even afford to buy books,
our libraries were not good.
We didn't have books
the books that were there were very old ones.
If your professor wanted you to read notes or an article you go and photocopy.
So you pay
you pay money to get notes
I don't think there is quality in girls' education – To actually get into a university
You have to be 100% perfect
The payment plan was nowhere near easily accessible – In my country
Civil war began when I was five years old.
My mother taught me how to read my language, and how to write – [Here]I
decided to go back to school
I started with a Master's in African Studies Yes, I was from Africa
But I had very little information about Africa

(Haki, Chrisette and Naima)

Based on the aforementioned poetic transcription (changes in speakers are indicated with –), it becomes clear that the educational spaces the participants navigated in postcolonial Haiti, Jamaica, Somalia (no actual educational space was navigated), and Kenya were economically deprived. At the same time, academic

rigor, for example expressed in the requirement of writing by hand or extreme selectiveness on part of universities is likely to be connected to this deprivation and make the United States more attractive for educational purposes. However, the reality of this attractiveness becomes more relative to the women as they actually navigate the educational spaces in the United States. Marisha thus notes in our interview that she did pursue a Master's of education in Jamaica, because of the schools' selectiveness and lack of an affordable payment plan, but mostly, because the pay increase she would have received after completing her degree would have been marginal. Later in the conversation, she admits that the pay increase in the United States is also not significant, but that she felt the program was more accessible at the university she attended.

The idea of access, particularly with regard to educational spaces and facilities, is a re-emerging theme that also shows itself in the other poetic transcriptions and narratives. Considered in the contexts of countries that still adhere to colonial systems (e.g. Jamaica continues to operate based on the British system of A-levels and O-levels), these narratives help us understand how the deprivation of these educational spaces, along with a discourse of superiority, contributes to America being a desirable place for the pursuit of education.

Marisha, for example, points out that pursuing a Master's degree in Jamaica, her home country, was difficult due to the competitiveness of programs that resulted in a payment plan offer that she could not afford and being placed on a waiting list, because at the University of the West Indies "they wanted the best of the best." She cites the shortage of jobs and resulting brain drain as reasons for the competitiveness. While she felt alienated in her process of trying to access a program in Jamaica, because "they weren't working with you to get in" (Interview 2), American enrollment officers courted her and made her feel welcome when she expressed interest in pursuing her Master's degree in the United States. Interestingly, when the programs are compared, the program in Jamaica cost roughly half of the program she eventually completed.

Naima similarly notes that without coming to America, she would not have been able to pursue her educational goals, since Somalia did not have formal education when she was a child. America, the women agree, does provide levels of access and opportunity on various levels that are denied in other places. However, all participants except for Tee, who has been spending time in both countries, pointed out that the downside to America is the sense of isolation or as Haki remarks that "you're suffering and nobody cares," whereas she felt cared for and connected in her home community. Of course, the process of uprooting one's life and moving into a community in which one is less connected can be isolating no matter where one lives. However, the type of isolation Haki, Marisha, and Naima talk about is presented in stark contrast to the various opportunities for educational advancement that are present in the United States. Thus, as the poetic transcription on the previous page reflects, even though there may be water, electricity, and access to education that promise pay increases, what is missing is the humanness, care, and ability to hold on to one's culture. Thus, the only time that Marisha notes during the interview that she feels welcome is when she talks about

meeting a fellow Jamaican woman in the grocery store, and when she talks about the recruiters who were helping her to access graduate school. She notes:

> I had an advisor call me every week, "how are you in this process, how are you?" It's like they want me to get in. The motivation was like – 'Okay, so and so is going to call me, let me make sure this transcript is here'. They made me feel like 'oh you're so welcome. I want you here.' And then, I'm trying to get in but there's that barrier that's preventing that from happening.

Although the advisors made Marisha feel welcome in terms of supporting her in entering a program, barriers remain that keep her in the same place. The program she would truly like to pursue for her doctorate degree (curriculum/instruction and administration) is out of her reach, because she has resettled in South Carolina and does not want to uproot her family to pursue her own goals. In many ways, Marisha reproduced the rhetoric of the American Dream: "If you work hard and play by the rules you should be given a chance to go as far as your God-given ability will take you" (Clinton, qtd. in Hochschild, 1995, p. 18). With respect to education and home ownership, she notes that the opportunities in the United States empowered her to change her thinking from "It's going to be too expensive, it's too hard" to "why not go further" and "the sky is the limit."

A stark contrast to the narrative of America as rich in opportunity and amenities but lacking in humanity, community, closeness, and an overall sense of well-being was the notion of home. Marisha, Haki, and Naima in particular constructed home as not only a place that felt familiar, but also a place that did not invoke stress. The three of them described missing not only their families, but also the atmosphere of familiarity, superior food, access to childcare, and a feeling of being connected. Home, then, for these three participants in particular is the place that may offer fewer economic advantages but is rich in emotional fulfillment. An important aspect of thinking through home was also the re-creation of spaces in the United States that provided a semblance of the home community they left behind. However, Haki notes that she tried to be part of the local diasporic Kenyan community but that her advanced educational level alienated her from the rest of the community. She argues:

> I know people and I have attended one of the Kenyan community churches, but I also feel like they also start to isolate you and especially if you decide to be different from them. Most Kenyans – I mean the ones I know, maybe others are different – but the ones I know they come and get stuck. People want to work the nine dollar job, the ten dollar job, those shifts, where you work like three shifts in a nursing home. Those low jobs and maybe at home, you were working a very well-paying job, but you come here and you get stuck. You decide to advance your education, you become different and people start looking at you like "Oh, she is . . . she thinks she is special. . . . I don't feel like I belong there."
>
> [Interview 1]

Thus, the paragraph indicates that her educational level is the reason for being isolated by the rest of the community she tried to re-create, mainly due to her pursuit of upward mobility. Therefore, home is . . .

> *When you go outside*
> *You're not looking at strangers*
> *You're not looking at empty buildings*
> *And people who don't even say hi*
> *Home really is Jamaica*
> *When you feel woozy and homesick*
> *That's where I want to go –*
> *Home is where the heart is and my heart*
> *Is in Kenya*
> *It's the food Going to the market*
> *Getting people to laugh with you*
> *The small things*
> *There is a sense of community*
> *If there is a wedding, people will come*
> *They'll help you cook*
> *Prepare for visitors*
> *When my grandpa died*
> *A school that was nearby*
> *Had to close for that afternoon*
> *So they could attend the burial*
> *We did not even go there –*
> *My mother's cousin has eight kids*
> *They are happy*
> *They are smiling*
> *They are talking*
> *When she wants to cook the tea*
> *She goes to the neighbor*
> *"Maybe I can borrow sugar"*
> *She doesn't have any stress –*
> *I think I miss the warmth-*
> *The warmth of the people*

Despite attempts of re-creating a sense of belonging, Haki, Naima, and Marisha agree that home is in the place they left behind. Similarly to Haki, Marisha says she tries to re-create home by trying to become more involved in her husband's family, who not only is American, but was also born and raised close to where they decided to settle. She says:

What I thought of trying, since now I have family here – what I did this summer was try to bring families together just to have that family thing. We had cookouts and family gatherings and everything. Just to get that kind of

atmosphere where we would all gather in one place and eat and talk and drink. . . . It made me feel a little bit more comfortable that, even though these are families that are inherited, somewhat, I still felt that little family thing. But even then, after all that, I'm like "Oh, my mom, my dad, my sisters. "And you still think: "They should be here too."

Thus, Marisha and Haki both seek to re-create community in their new locations by drawing on networks that are based on ethnicity (Haki) and familiarity (Marisha).

However, in Haki's case, this creation of community is difficult because of the class difference, which she perceives to be rooted in her own educational advancement. Marisha's attempt to create community with her husband's family, on the other hand, is impacted by the absence of her parents and siblings. Thus, the ability to create or re-create a community that feels like 'home' is difficult, albeit desired by all participants, except Tee, who argues that she enjoys and prefers anonymity to community.

Accentuated difference

Naima and I have been maintaining our tutoring-relationship-turned-friendship for 3 years. Since then, I have seen her try to access and navigate various educational spaces, including English as a Second Language (ESL) classes, GED classes, and courses at a technical college. As I discussed in previous chapters, I met Naima through a colleague of mine whose ESL course she was taking. After meeting in a public place for the first few weeks of our tutoring arrangement, I started coming to her home. ESL tutoring turned into a request for tutoring in math and social studies, in addition to ESL. With it came visits to colleges, test preparation, emailing teachers to ask them for more tutoring when I wasn't available, and ordering books through my Amazon.com account.

To this day, I often forget that Naima did not have access to formal education until she came to the United States at the age of 19. She is simply brilliant and grasps linguistic and mathematical concepts in very little time. Despite her outstanding abilities, I have watched her struggle and fail when it comes to completing courses to complete her GED, particularly as the lack of a high-school diploma requires her to cram 12 years of schooling into a few courses. I have watched her make plans in frustration to move to India alone, leaving her family behind for 1 year, to complete a computer science course in India that one of her friends from her GED class told her about, only to abandon these plans when she finally passed the test to advance to the next level in her class.

She is a wife, a mother of four small children, and an advocate for her family in the United States and Somalia. Her husband drives trucks across the state all day to enable her to stay at home, which is why she has often relied on me for day-to-day tasks that require accent-free English in her mind. In the beginning, I was mildly annoyed that my hours of preparing math problems (including the various ways to explain them) and texts for reading would be barely touched, while we spent 2 hours on Internet searches, paperwork, and phone calls (for which I generally did not accept the 10 dollar per hour remuneration on which she insisted). However,

I quickly caught on that Naima was indeed right. My neutral accent provided her with access to information and/or kinder treatment that she did not otherwise have.

I admit that despite my advanced degree in linguistics and sound theoretical knowledge of linguistic profiling, I was ignorant about what having a strongly identifiable accent, along with other markers of difference, means in the day-to-day lives of those who experience marginalization because of this difference. I was raised in a household with a mother who initially spoke English but quickly learned German. I refused to speak English to her until I was a teenager and, much to her annoyance, always reminded her that in Germany, we have to speak German. However, during my adolescence, I and most people around me were so impacted by hip-hop culture that I spent hours emulating American speakers, and my weekends were spent trying to make American friends around the countless U.S. Airforce and Army bases that surrounded my hometown. I had carefully cropped the German corners and edges off of my own accent even before I ever came to the United States in my early 20s. I remember blushing with pride when a professor proclaimed in front of class how "amazing" I was as a person who spent her formative years in Germany, because he couldn't perceive a hint of accent in my voice during my exchange year in Tennessee. Now, almost fully assimilated in terms of speech sounds, I recognize this as a privilege, as I have never experienced the kind of treatment that is associated with linguicism (Harushimana, Ikpeze, & Mthethwa-Sommers, 2013).

One summer afternoon, Naima asked me to call a DNA testing center, from which she had obtained a quote to conduct DNA testing on her mother as part of the family reunification visa program. Our planned 2-hour "tutoring" session had already exceeded 3 hours, and I was reluctant when she asked me to call the same agency pretending I was her because she believed it would lessen the quoted amount of $720. I told her that I did not like to lie and pretend to be her, since I could only imagine the discomfort I would experience I was asked identifying information about her mother, but she insisted that I did not identify as a proxy, or friend, as I usually did. "Don't say you're calling on behalf of Naima this time," she said with a stern expression. I tried to hide my annoyance, mostly because I thought that it would be a waste of time. After all, a quotation from a government-affiliated agency certainly would not change, just because I called with my assimilated accent. But I conceded, because I know that every cent counts, especially for a family of five, whose expendable income also supports numerous relatives in Somalia.

The verified quote they sent to me after a 10-minute conversation was priced at $ 500, 220 dollars less than the quote she was sent when she called. A part of me continued to believe that certainly there must have been a logical explanation as to why the two different quotes were provided, but there is no explanation other than a mistake at best, and a deliberate practice that takes advantage of immigrant families, whose English proficiency is perceived to be limited, at worst.

Race and skin tone

Race and skin tone have been topics of conversation since the first conversation I've ever held with Naima. During that first conversation she asked for pictures of my family and concluded that if her husband were white, her children may have looked

like me after reading my mother's skin tone as darker than her own. "I thought you were White, or Mexican" were her words that clung to me for months after she said them and that reopened and closed questions about my own phenotype and hair texture. The topic came up a few times more, especially since Naima often asked me to help her make sense of her own racialized or intra-racial experiences. For instance, I recall feeling shock when she asked me why there were so many African Americans in her GED classes. Shouldn't this be beneath them, since "they" know English and have access to education? She asked why her African American classmates huddled outside to smoke during breaks in the bitter winter cold. "Don't they know it's unhealthy and disgusting?" I grasped at words, concepts, and ideas, trying to explain the interconnections of racial inequity and education in the United States.

We talked for a long time, yet I felt I was asked to speak on an experience that was not my own and defended her classmates, whom I did not know, primarily, because I had read the research on Black immigrants (Moore, 2013; Waters, 1999) that pointed out how they excelled in terms of upward mobility when compared to their African American peers, without ever questioning the privileges and contexts that create these possibilities. During our interview, race and skin tone privilege re-emerged, of course, due to my questions about racism and identity but in ways I did not expect. Similarly to Haki, Naima did not identify as African or Black when she lived in Somalia, but as a Somali.

The exchange that follows shows, however, that to Naima the identities of Black, African, and Somali were all not only contextual, but also her identity as "African" was tied to skin tone.

TANJA: Would you say your identity has changed since you came to America? Did you see yourself as a Black woman before you came to the United States?

NAIMA: Ask me again? I don't understand.

TANJA: Did you see yourself as a Black woman before you came to the United States?

NAIMA: When I was my country, I think I'm Somali and I'm [inaudible] and I didn't see any different, but when I came here and I see different colors, and different people, I see I'm Black, right now. I believe that, so you're going to get – when you live in your country you don't know really the Black or White, or if you're different, or if you same because it's your country, and nobody going to treat you different. But when you come another country that's the time you're going to get experiences with the different people, and different colors, so right now I'm see I'm Black.

TANJA: And in Somalia did you think of yourself as African?

NAIMA: [laughter]. No.

TANJA: No? Just Somali. What about now? Do you see yourself as more African, or Somali, or equal, or . . .?

NAIMA: I see right now I'm an African and I see right now I'm Black. When we live in Somalia I just see I'm Somali, but I think I'm not African because I'm a little bit light skin, and Somalian people have – what do you call? [points to her nose] So we think we're not African; but right now I see I'm African and Black one.

Based on the aforementioned exchange, then, Naima's racial identity changed when she came to the United States, and she began to be identified as Black after encountering people from various backgrounds. More interestingly, however, she notes that she did not see herself as African in Somalia, not necessarily due to a lack of knowledge of the rest of the continent, which was Haki's reason for wishing to be specific, but because she saw phenotypical features, such as lighter skin tones and narrow noses as indicators that Somalis are not African, and that this is a marker reserved for "West African" people. Later on in the interview, I ask her about racism and Somalia, which she initially notes is not truly about race but about the oppression of smaller clans. Then, she argues that it is "racist everywhere," after noting the following:

> People like me, we have a little bit of light skin, and our nose and our hair is kind of soft. That's the majority of people, they thinks they're cute and they're good.
>
> That's majority. And all of the presidents become that kind of people. But we have people have big nose, like Western African. They look like more Western African, and they're minority. So that people doing down jobs like janitor or something like that, and maids.
>
> [Naima, Interview]

Thus, Naima points out that while "racism" in the form that she would identify does not exist in Somalia, colorism does exist and works to oppress West African people, or those who look like them (identified by darker skin, broader noses), and also impacts social stratification. After attempting to continue the interview, Naima ignores my next question and tells me with urgency: "Even they don't marry each other, you know," by which she refers to lighter-skinned East Africans and those who are identified as West African due to their darker skin. She notes that intermarriage is frowned upon and provides the example of one of her cousins, who was not able to marry her darker-skinned spouse until they moved to the United States. "Here it doesn't matter," Naima notes. Thus, despite the colorism and racism that exists within the United States, the particular racial (or intra-racial) issues that exist in Somalia are not of importance here and create a space for relationships that would have otherwise not existed. Naima's insights into her self-identification are particularly rich from a transnational Black feminist perspective, considering the ways she positions her self-identification across space and time in her story. Prompted by my question, she begins describing her identity in the present moment, where she identifies as African and as Black after having spent roughly 15 years in the United States. However, considering her racialized and classed experiences in Somalia in which darker skin and what she considers "West-Africanness" were not only markers for what it means to be "Black" and "African," but also markers for social class, it becomes quite apparent that racial identities must be considered both in terms of her current experience and identification, as well as the ways race is constructed in her upbringing in order to fully understand what it means to be Black for Naima.

Tee and I

The first time I saw Tee, I was getting my hair straightened by one of her colleagues at a chic salon in my hometown. It was the only recommendation hairdressers in Germany, both Black and white, had for styling my hair. Her own straightened hair fell fair down her back and was highlighted with golden blonde streaks. To this day, we cannot recall how we struck up an initial conversation, whether it was at the salon or seeing each other out and about at one of the clubs frequented by American soldiers and German locals. However, we both recall for a fact that we sought each other out because we identified each other as Black women in an almost all-white town. Tee is 2 years younger than I and from a few towns over from my hometown, where she used to work until enrolling to become a full-time student. When we first met, I was a 21-year-old undergraduate student, and she was a licensed hair stylist. Based on the German educational system, students can graduate after 9th, 10th, or 12th (in some cases 13th) grade and pursue careers either on an apprenticeship model.

I remember sitting on the couch in her mother's apartment, where she told me how inspired she was about my educational pursuit and her goals of returning to school to add qualifications that would allow a change in her career. She stopped hairdressing and returned to school and is now in the fifth year of her bachelor's degree in Retail and Service Management and is planning to pursue her M.A. in logistics, which she would like to complete in Germany. She notes that she would prefer to complete her graduate education in Germany for financial reasons.

Transnational Black/white identity

Tee disrupted so many of the consistent themes that emerged from the data I collected from the rest of the participants. Tee is biracial, bicultural, and bilingual. Her mother is a white German woman, and her father is African American from Florida. She spends half of her life in Louisiana, where her fiancée was stationed, and the other half in the Southern part of Germany, where she is attending school. In Germany, she lives with two roommates and says she enjoys the anonymity of being away from home.

Whereas all other participants highlighted the importance of community, Tee notes how important anonymity is for her. Where she lives now, she argues, she has been able to reinvent herself and move away from the constraints of how others perceived her.

At home, she says, people still see her as the young woman, "who is unable to achieve anything" ("die nichts auf die Reihe kriegt"). The following paragraph reflects how Tee constructs anonymity as more desirable than community: "Ich geniesse eigentlich in. Bayern meine Anonymität, also das ich in [Heimatstadt] nicht hab. Wenn ich jetzt in [Heimatstadt] bin kenn ich nen Haufen Leute, ich muss 'hallo' sagen, naja ich muss halt in Landau ständig mit jemandem reden, oder jemanden sehen, was machst du denn gerade" (*Translation: I am enjoying anonymity in Bavaria, which I don't have in [hometown]. When I'm at home, I know tons of people, I have to say hello, well, I constantly have to talk to people, or see them, and they ask what are you doing?"*).

Tee thus enjoys anonymity, because she is able to live in her current space without the low expectations of her home community, which included the expectation of academic failure. She says these expectations result from her upbringing in a dysfunctional environment, which was created by both of her parents.

Although she was born in Germany, her parents moved to the United States when she was 6 months old and stayed there until she was 7 years of age, when her parents ended their relationship. In our interview, which we conducted in German, she describes the day she was kidnapped by her father as follows:

German original text:

TEE: Ich bin in Deutschland geboren, bin dann mit einem halben Jahr rüber und war da bis ich sieben war.

Bin dann wieder zurückgekommen dann hat mein, bis ich 12 oder 13 war, dann hatte mein Vater mich entführt Also es war halt noch vor 9/11, wo du halt tatsächlich auch noch ins Gate reingekommen bist, das ist ja heutzutage gar nicht mehr denkbar, er hat mich vom Gate im Atlanta Flughafen einfach raus und mitgenommen und mich einfach net zurückgeschickt.

TANJA: Was? OK!

TEE: [lacht] Also ja, doch, also man kann schon sagen entführt – also meine Mutter hat mich rüber geschickt und mein Vater hat mich einfach am Flughafen entführt.

English Translation

TEE: I was born in Germany and went over [to the U.S.] when I was six months old, until I was seven. Then, I returned and then my, well until I was 12 or 13, then my father kidnapped me –

TANJA: What? Ok!

TEE: [laughs] Well, yes, you could say kidnapped – Well, my mother sent me over and my father kidnapped me at the airport. It was before 9/11, when you could still enter the gate, which is unimaginable nowadays, and he simply took me from the gate at the airport in Atlanta and did not return me.

This story is significant for two reasons; on the one hand, it illustrates the transnational nature of Tee's life: she spent her early childhood and adolescence on two continents, which she continues to do well into her adulthood. More importantly, however, when I asked why her father went to the great lengths of kidnapping her, after which she lived with him for 9 months and was enrolled in school in the United States, she noted (original):

I mean, it was kinda like, he wanted me to be under Black people. Er wollte mich eigentlich unter Schwarzen aufziehen. Er meinte ich soll zu meiner, wie soll ich das sagen, ich sag es jetzt mal ein bisschen krass ausgedrückt, ich soll zu meiner Rasse gehören. Ich würde meine schwarze Seite einfach ein bisschen verlieren. "
(Translation: "*I mean, it was kinda like, he wanted me to be under Black people. He wanted to raise me among Black people. He thought I should – I'm*

not sure how to say it, I'll say it in a crass manner – I should belong to my race. That I was losing my Black side.").

Thus, Tee's father noted the potential loss of her racial identity, which he believed would be inevitable, if she had been raised by her mother in Germany, as the reason he took her from the airport when she was supposed to be on her way to visit family members. As she notes, he wanted Tee to be raised among Black people and Black culture and found it important to develop a Black racial identity. However, Tee's racial identity is quite complex. In the interview, she mostly used "Hautfarbe" (*skin color*) to talk about race, mainly because the German word for race ("Rasse") is quite negatively connoted due to its usage during national socialism (Guillaumin, 1992).

Tee argues that in Germany, she does not see herself as mixed or light-skinned, but "hunderprozentig schwarz" (*one hundred percent Black*). In the United States, however, she sees herself more as white than as Black. She notes on the one hand that this place-based experience of racial identity is due to the type of *"severe racism"* ("krasser Rassismus") that exists in the United States and is difficult for her to grasp, which makes her feel out of place. On the other hand, she notes that outside of her family, she feels more comfortable among white people in the United States for the following reason:

> Weil ich aber auch oft mit dieser ratchedness, und dieses Ghetto – weisst du, ich kann mich damit nicht identifizieren und das heisst nicht, ok, I'm not trying to, you know, this is not stereotyping, that's not what I'm trying . . . – aber es ist oft so, dass wenn du unter Schwarzen bist, its getting real ratchet real fast, and its ghetto real fast, und das, das hast du bei weissen natürlich auch, aber das sehe ich bei schwarzen ganz, ganz viel.
>
> (Translation: *Because I can't identify with this ratchedness, and this ghetto – and that doesn't mean, ok, I'm not trying to, you know, this is not stereotyping, that's not what I'm trying . . . – but often, when you're among Black people, it's getting real ratchet real fast, and it's ghetto real fast, and that – of course, you also see this among White people – but I see it among Black people a lot.*)

Taken together, then, Tee constructs her racial identity not only in relation to place, but also in relation to the contexts at play. For example, she notes that she cannot fully grasp U.S. racism (she cites police brutality and the rhetoric that undergirds Donald Trump's election as reasons). Further, she also argues that she more with white identity in the United States, because of what she describes as "ratchetness," or "ghetto" behavior from which she is distancing herself. In the same vein, she notes that while the label "ratchet" neither applies to her fiancée's friends and family, nor her own family, she notes "when I'm among ratchet people, I feel weird."

I wondered who exactly Tee was talking about, since she was sure to differentiate between "non-ratchet Black people," such as her own relatives and her

fiancée's family and friends. Of course, the notion of "ratchetness" is also raced, classed, and gendered.

According to Brown and Young (2016) the term "ratchet" is deeply connected to the lived experiences of working class African Americans in the South and particularly used in reference to poor women of color, who do not behave in ways that are deemed respectable. When I ask Tee what she means by ratchet, she describes it as following:

> Eine mit fünf babies und schon wieder mit dem nächsten schwanger, mit sechs Baby-daddies, collecting five welfare checks and five child support checks, and is acting ratchet. Weisst du so, die loud, and looking like a hot mess, and the pink hair and the weaves and wigs and the, you know what I'm saying? Einfach dieses ghetto. Und ich find wenn du schon schwarz bist, dann musst du, you need to look decnt, if I go to a job interview, trust me, I got my polo on, and my boat shoes, and some Michael Kors jeans, or whatever, I'm looking decent. Why? Because you need to let these people know, hey, my skin color might be different, But I'm still the same. Es geht halt viel über Kleidung. Das ist halt leider so.
>
> (Translation: *A woman with five babies, pregnant with the next one, with six baby daddies, collecting five welfare checks and five child support checks, and is acting ratchet. You know, she's loud, and looking like a hot mess, and the pink hair and the weaves and wigs, and the – you know what I'm saying? Just ghetto. And I think if you're Black, you have to, you need to look decent, if I got a job interview, trust me, I got my polo on, and my boat shoes, and some Michael Kors jeans, or whatever, I'm looking decent. Why? Because you need to let these people know, hey, my skin color might be different, but I'm still the same. That's done with clothing. That's how it is, unfortunately.*)

In the aforementioned paragraph, Tee offers an explanation of who is "ratchet" in her eyes – a loud-mouthed, welfare, and child-support collecting woman, who styles herself in wigs and weaves in a way that is undesirable in the workplace. Thus, Tee evokes negative discourses about Black womanhood, such as the imagery of the "welfare queen," from which she seeks to distance herself. According to Hancock (2004), "the public identity of the 'welfare queen,' is grounded in two discursive themes about Black women traceable to slavery: their laziness and their fecundity" (p. 6). Thus, the welfare queen is a Black woman, usually a mother, who takes advantage of the benevolence of the social state by refusing to seek work outside of the home.

Tee's discussion of what it means to be "ratchet" and "ghetto" (or not) is further embedded in a larger context of respectability politics, as she notes that it is especially important to look "decent" if you are Black. The ideology behind respectability politics is the notion that marginalized people, particularly African Americans, must present themselves in ways that are acceptable in white spaces by maintaining hairstyles that are deemed professional, such as straightened hair

for women, and men "pulling their pants up," as President Obama famously required of Black men (Montopoli, 2008). These efforts, then, should facilitate upward mobility and assuage the negative stereotypes connected with Black people.

Although Tee code-switches throughout the paragraph, she begins the sentence in "Wenn du schon schwarz bist . . . " in German, which carries meaning beyond "if you are Black," and that indicates something to the effect of "if you already have being Black working against you," it is even more important to look 'decent', particularly in the workplace." Harris (2014) points out the interconnection of respectability politics and neoliberalism, noting:

> In an era marked by rising inequality and declining economic mobility for most Americans – but particularly for Black Americans – the twenty-first-century version of the politics of respectability works to accommodate neoliberalism. The virtues of self-care and self-correction are framed as strategies to lift the Black poor out of their condition by preparing them for the market economy.
>
> (p. 33)

Based on Harris' (2014) explanation of how neoliberalism and respectability politics are entwined, it is no surprise that Tee continues her discussion of appropriate interview clothing by naming name-brand items, such as Michael Kors jeans and Polo shirts, which also carry a type of symbolic value.[1] Tee concludes her point by noting *"on the issue of racism, I always tell my boyfriend: Black people need to work on themselves first, before they can complain about anything. We need to get our shit together first. We have to start by helping each other, instead of working against each other."*[2] Thus, Tee places the onus of responsibility of working against racism on Black people. She clearly situates herself as a Black woman in this explanation by using the collective "we."

Tee constructs her own racial, gendered, and classed identity not only based on space and place, for example, by identifying as Black in Germany and white in Germany, but also in relation to and in opposition of the negative stereotypes that exist about Black women. She notes that her mother and father raised her in an environment that was not stable or desirable, as her mother continues to draw financial support from the German government, even though her parents were professors. Tee's relationship with her parents remains troubled as she continues to pursue education for the purposes of upward mobility. According to her, it is for this reason that she excluded careers in the social sector and decided to focus on business and management.

National identity and allegiances

Tee's national identity is also within an both/and space, as she identifies as both American and German equally, but says she feels divided, as she constantly draws comparisons between Germany and the United States.

She argues that she misses the United States when she is in Germany and misses Germany when she is in the United States. Thus, her ideal situation would be to live in Germany but on a military base, which would provide her with access to American food options, English speakers, as well as affordable German groceries and a sound social system.

In Germany, she says, she has never felt at a disadvantage due to her skin color, while she worries about the racial climate in the United States, particularly with respect to men. She points out, however, that the German service culture there has created a host of negative experiences for her with salespeople, who talk to her as though she is stupid or do not pay attention to her. Of course, she notes, this, too, varies by region. Bavaria, her current region of residence, she notes, is a lot less accommodating to other cultures than her hometown in the Rhineland Palatinate.

Conversely, she argues that white people in Germany often touch her hair without invitation or permissions. She also points out that professors often make decisions that count against her, such as requiring her to retake courses when they could allow her to retake the test. As one of the three people of color in the school, she finds that she stands out.

Tee initially argued that racism was more extreme in the United States, as well as gendered and therefore much worse for Black men. However, she notes that after thinking more deeply about these experiences during our interview, she begins to understand her father's desire to raise her in a Black community. In this context she notes:

> Wenn ich dann sowas, dann wieder sehe, dann denke ich mir, ok, vielleicht verstehe ich irgendwie schon was mein Vater gemeint hat, mit sei unter deines Gleichen, ja. Aber ich bin einfach strikt gegen Rassentrennung. Ich hatte schon immer ausländische freunde, deutsche freunde, schwarze freunde – as long as you're not ratchet.
>
> (Translation: *When I see this kind of thing, I think, ok, maybe I understand what my father meant by "be amongst your own kind", yes. But I am simply against separating races. I have always had friends who were foreigners, German friends, Black friends – as long as you're not ratchet.*)

This comment also reveals a subtle hint toward German identity. By pointing out that she has always had foreign friends, German friends, and Black friends, Tee separates Black identity from German identity. El-Tayeb (2011) calls this "invisible racialization," a process of racialization that persists in Europe. Invisible racialization, then, "is the peculiar coexistence of, on the one hand, a regime of continent-wide recognized visual markers that construct nonWhiteness as non-Europeanness, with on the other a discourse of colorblindness that claims not to "see" racialized difference" (El-Tayeb, 2011, p. xxiv). This theme emerged also in one of my own recent experiences, which I had shared with Tee.

A few weeks ago, in early March 2017, I went to take passport pictures for my daughter and myself. The professional who helped me processed my pictures, when an older white man approached, standing at the counter. He started

becoming visibly restless and rang the bell, even though the clerk was working on my images only a few feet away. While I was paying for my pictures and waited for the clerk to put them into envelopes, he asked if I was "planning on taking little one out of the country," and I said, yes, maybe Germany. That's when his questioning became more intense. Why Germany, he wanted to know, which part, and were my parents in the military? The clerk shared a brief story about a friend who grew up in Germany, but the old man was relentless after I had identified as German without any military affiliation. He began speaking in German with me and pretended not to understand me when I responded. I told him we had to go, said goodbye to the helpful clerk, and made my way to the parking lot. After strapping my baby into her car seat and getting into the front, I could see that the man's gaze had never left me. This wasn't my first experience in which language, national identity, and a reading of my body seemingly conflicted so much that it caused my being bombarded with questions by white Germans. I shared the moment with Tee, in a text message, which is reflected as follows.

My message to Tee reads,

TANJA: Ein alter deutscher Mann bei CVS hat mich grad ausgefragt und angezweifelt, ob ich wirklich deutsch bin.

TEE: Ja, die kommen damit net so klar. Das hatte ich auf der Cruise auch, Ich hatte so ein älteres deutsches Paar, oder ich glaube, die kamen aus Österreich, und man erwartet halt nicht aus unseren Mündern Deutsch zu hören, ja. Und vor allem sprechen wir ja auch noch Englisch ohne Akzent, und dann kapieren sie das erst recht nicht. Und die auch erstaunt, und total überfordert, ne. Total krass.

TANJA: An old German man at CVS just questioned me and doubted that I'm really German.

TEE: Yea, they don't handle it well. I experienced the same thing on the cruise.
There was this older German couple or maybe Austrian. People just don't expect to hear German to come out of our mouths, especially since we don't have an accent in English. And they don't get it and they are also overwhelmed. It's crazy.

I found it curious that my German national identity was challenged in the United States, which is a racialized experience usually reserved for German spaces in the United States. Tee makes the connection that this identity is tied to language, as she asserts that white Germans "just don't expect German to come out of our mouths" (original given before). Full German citizenship, based on the experience discussed before, as well as in Tee's experience on the cruise ship, then, is only accessible through whiteness. This moment was significant for this study, because it highlights some of the ways that whiteness and racialization occur transnationally, yet are very closely linked to national identity (even if they occur outside of the nation-state, such as on a cruise ship).

Conclusion

Although there were more, the most salient themes that emerged from my interviews and interactions with Black transnational women included the complexity of racial identity at the intersections, the importance of community and its re-creation, the realization of an American dream that is rooted in educational access, and the importance of language and literacy for making educational goals attainable. It is my argument here that, of course, all participants experience being and becoming Black transnational women in their own way. Visa status, religion, and nationality play a role in how these identities are perceived, developed, and assessed. However, the findings of this study show that the knowledges of Black transnational women, particularly knowledges of race and racism, are impacted by both the way race and racial hierarchies operate or do not operate in their countries of origin, as well as in the United States.

Haki pointed out that everyone in her Kenyan home community was Black and that racial stratification was along skin tone and class. Interestingly enough, she uses 'Black' as an identity marker to refer to a community that does not use it. One country over, Naima notes that Blackness was considered a trait of West Africans, who made up the lower rungs of society in her Somali community. These are indicators that "there is racial stuff everywhere" (Maya, Interview) and that the constructions of race are often quite similar, as they are organized around skin tone and privilege, which in turn impact educational access.

America, for many of the participants, is indeed a place of access and opportunity, particularly when it comes to education. However, almost all of the participants expressed the desire of returning *home* into communities in which they felt welcome, valued, and familiar.

Notes

1 I situate this idea of symbolic value within Crane and Bovone's (2006) discussion on fashion and values, in which they assert: "Material goods express values; consumption of these goods is a means for the consumer to communicate messages about the values she holds" (p. 320).
2 The original: "Zum Thema Rassismus, ja, ich sage immer zu meinem Freund: schwarze müssen erstmal an sich selbst arbeiten, bevor sie sich über irgendwas beschweren. We need to get our shit together first. Wir müssen uns erstmal gegenseitig helfen, ja nicht gegeneinander arbeiten."

4 (Re)considering reciprocity and exploitation

Throughout this project, I worried about potential exploitation and violence I could inflict by separating the needs and desires of my researcher-self (producing research that is rigorous, "truthful," and trustworthy) from my needs and desires as a family member and friend (being loyal and trustworthy, caring and loving). I wanted to engage in a reciprocal process in which the relationship I maintain with my research participants, who are friends and family, overrides the need to present and share sensitive data, even if they were compelling. This often meant trying to be discerning in murky waters. However, from a Transnational Black Feminist perspective, the need to think critically about engaging in solidarity, coalition-building, and taking seriously the intimacies necessitates researchers to think about what exploitation and reciprocity may mean in their particular contexts.

I share Harrison, MacGibbon, and Morton's (2001) concern "with issues that are sometimes difficult to articulate but include rapport, safety, honoring, and obligation" (325). I knew that some of my family members and friends were at risk of deportation or scrutiny by governmental agencies and learned about others holding views, beliefs, and opinions that strongly differed from mine, which I had not known about until we had candid discussions throughout the research process. I did not want to engage in a research study that would require me to take data from participants without providing anything in return, particularly as it would reiterate dehumanizing (Paris & Winn, 2013) and colonial approaches to research (Smith, 1999). As Plummer (1983) notes, participants are often shrouded by anonymity, while researchers benefit from their data to gain status, publications, or, in my case, to complete a degree. However, thanks to my pre-existing relationship with participants, I was able to minimize the risk of exploitation. For example, even before I engaged in the research process, I was involved in providing certain participants with ESL tutoring, support with English-language paperwork, providing peer mentoring and support, and other activities, all of which carried over into the data collection process.

I still encountered dilemmas that stemmed from my desire to counteract the power dynamic of exploitative research. For example I realized quite frequently that at times, I made myself available to Chrisette up to the point of my own detriment, because I wanted to continue my role as their neighbor or friend and feared

DOI: 10.4324/9781003056621-5

that me declining to provide a ride in my car, stand in line at job centers for hours, or babysit late at night after a long day would negatively impact our relationship, which had already taken on different dimensions due to the research being conducted. Ironically, it was my researcher role and the thought of using the data they provided that put me in a position in which I never said no, even if it required time, energy, and money on my part.

Thinking through power and relationships with Chrisette

When I met Chrisette in front of the mailboxes in the apartment building in which we both lived, I didn't know what to make of someone who so eagerly struck up a conversation with me. The apartment complex is quite large, looks a bit run down, and within the price range of a graduate student (me) or an undocumented immigrant woman with a toddler (Chrisette).

Even though a group of neighbors enjoy sitting outside, the conversations I have had with other tenants usually never went beyond a greeting. Thus, when Chrisette spoke to me and her conversation so quickly moved from fashion to the devastating death of her newborn, I became so uncomfortable that I wanted to run. Certainly, this woman would want something from me, and I figured it was money. There we stood, shivering, while tears streamed down her face, and the story about her baby began to tumble out of her.

The coat she had complimented me on was purposefully large, because I knew a few months from then I would have to hide my not-yet-visible pregnant belly. "If you ever get pregnant, don't allow anything to stress you," Chrisette said. "It was stress that killed my baby." I couldn't bring myself to tell her that I was already expecting (and quite stressed out), even though she had disclosed so much of herself, it seemed beyond inappropriate to disclose this information, even dangerous. She asked if she could ever talk to me, and I told her I was happy to lend an ear. We exchanged numbers and I did not hear from her, and even though I thought of her quite often, I didn't feel comfortable contacting her.

In the spring, she called me and told me that a woman, who she claimed was my grandmother, visited her time and time again in a dream and told her to contact me, because I needed support. One day, she found the piece of paper with my phone number that I had given her on the floor behind her TV and decided to call me.

In addition to the mystical component to her story, her bringing up my grandmother added to my discomfort since my paternal grandmother Hilde passed away in 2009 and Hildred, my maternal grandmother, passed away in the 1970s. I had initially decided not to keep in contact, especially after listening to my mother's suggestion not to engage this stranger, but then promptly ran into her in a grocery store just a few days later. After that day, we celebrated each other's successes (e.g. finding employment) and mourned each other's losses (e.g. employers taking advantage of Chrisette's undocumented status by not paying her). Chrisette told me about her deteriorating marriage and her angry and spiteful

> Wow ! That's so much. When did you start working there ?

> Almost 2 weeks my friend, life it's hard when you don't have document in America,

Figure 4.1 Text message exchange with Chrisette (white background)

husband in Haiti, who resented her because her visitor's visa was approved, while his was denied. On numerous occasions, she shared with me his angry voice messages recorded in a furious mixture of French, Creole, and English, in which he threatened her. Their relationship worsened over time as he expected a child with another woman, and Chrisette pursued new relationships. In addition, he did not allow her to be in contact with the children that lived with him, which was another source of anxiousness and sadness for Chrisette.

Chrisette's message that "life it's hard when you don't have document in America," despite its simplicity, stayed on my mind since the day I received the message, even as I interviewed other participants or felt anxious about my own fears or employment limitations as a migrant on a student visa.

The absence of documentation not only generated fear or limited which jobs an educated and skilled person like Chrisette can actually obtain, it also made Chrisette one of the most vulnerable of the participants to potential deportation (in addition to Marisha who eventually obtained legal documentation), which, according to her, could very well have lethal consequences due to the violence to which she would return in Haiti. For an undocumented woman like Chrisette, the power exerted by the nation-state not only governs whether she is able to find employment that is not exploitative, pursue education, or the extent to which she worries about being found and deported, it also impacts how she structures her day-to-day life, envisions her future, and with whom she is able to talk about particular aspects of her life. During our interview, I asked Chrisette about her current work situation, a question that was included in my interview protocol. Her eyes narrowed as she firmly pressed her lips together and looked at the recording device. I realized that I had made a mistake. I reassured her then that the purpose of the question was not to expose potential illegal activity but merely for the purposes of understanding her professional and educational trajectory.

In a nutshell, Chrisette worked the kinds of jobs that would allow her to feed her toddler and allow her to survive. It was in these moments that I began to question what it meant to be in community with people whose needs varied so greatly and how this idea impacted the ways I had to think about the murky waters of conducting research with people so close to my life and so crucial to my own sense of community. Further, it made me question what the power relationship between us actually was rather than how it may have been perceived to be. I was not undocumented, but I was on a student visa while Chrisette and I interacted,

and I held very limited on-campus employment as a graduate student, which I was not legally allowed to supplement. I owned a car, which I had bought from a former roommate and was able to use to get to the grocery store. Chrisette knew that I would be willing to give her and her daughter rides in this car, but I was not the only person she could rely on. Her Haitian church community provided for many of her needs (paying for her rent, providing food and supplies).

In many ways, our shared experiences as nonresident aliens displaced many of the traditional researcher–participant power struggles and instead allowed us to lean on each other when necessary.

Life of a story

After hearing that her visa had expired, I brought Chrisette to an appointment with an organization for which I used to volunteer. The organization had just started a new program that would support individuals who qualified for the refugee process. According to United States Citizenship and Immigration Services (2015), a refugee must meet the following requirements to qualify for asylum: (1) be located outside of the United States; (2) be of special humanitarian concern to the United States; (3) demonstrate their persecution due to race, religion, nationality, political opinion, or being part of a social group; (4) not be resettled elsewhere; and

1. Why are you applying for asylum or withholding of removal under section 241(b)(3) of the INA, or for withholding of removal under the Convention Against Torture? Check the appropriate box(es) below and then provide detailed answers to questions A and B below.

I am seeking asylum or withholding of removal based on:

☐ Race ☐ Political opinion

☐ Religion ☐ Membership in a particular social group

☐ Nationality ☐ Torture Convention

A. Have you, your family, or close friends or colleagues ever experienced harm or mistreatment or threats in the past by anyone?

☐ No ☐ Yes

If "Yes," explain in detail:
1. What happened;
2. When the harm or mistreatment or threats occurred;
3. Who caused the harm or mistreatment or threats; and
4. Why you believe the harm or mistreatment or threats occurred.

B. Do you fear harm or mistreatment if you return to your home country?

☐ No ☐ Yes

If "Yes," explain in detail:
1. What harm or mistreatment you fear;
2. Who you believe would harm or mistreat you; and
3. Why you believe you would or could be harmed or mistreated.

Figure 4.2 Section 2 of United States Citizenship and Immigration Services Form I-589

(5) be admissible in the United States (www.uscis.gov/humanitarian/refugees-asylum/refugees). Filing for asylum and requesting "withholding of removal," meaning not being deported, on the grounds of being persecuted on the basis of the criteria presented under point 3 are possible for applicants who are located within the United States by filing form I-589 (www.uscis.gov/i-589).

The local organization that took on Chrisette's case had to prove that she met all of the requirements of the asylum process, particularly by focusing on the narratives of harm and violence (Figure 4.2). Members of the organization shared with me that this writing should be a compelling and eloquent plea containing detailed accounts of harm experienced.

I had heard the harrowing accounts of Chrisette's experiences at least six times under different circumstances; she told it to me several times, its emphasis placed on different parts of the story; I heard her tell it to my mother when she visited, as well as she told the professional working at a non-profit organization that agreed to support her. The story of why she needed to be in the United States was something she disclosed first to me as we sat drinking hot tea and eating fried plantains prepared by the woman she called "auntie" at her kitchen table. She showed me bite marks on her arms and told me of a family member who suffered a gunshot wound to the leg because of her involvement with the media. I noticed then that her storytelling was not chronological but rather marked by shifting back and forth between months and years, incidents, conversations, and emotions, mostly to illuminate the ways that the violence she experienced resulted in the death of her baby 21 days after she gave birth.

Even though doctors cited a heart defect as the cause of death, Chrisette is convinced that it was the trauma and anxiety that ended her baby's life. She told me the story a few times, always animated and with tears pooling in her eyes. Ultimately, she can't go back. She tells me that she would be picked out by those who mean harm to her; her light skin would immediately notify her tormentors of her return. I hear the story again in the office of a case worker whom I have come to know quite well during my months of volunteering. This time, Chrisette is telling the story slowly, with measured terms. The case worker asks questions that arrange the story along a timeline, such as "was this before or after . . .?", "what was the month and date of this incident?" Chrisette does her best to provide answers, but the reformatting based on months, years, and days translated from French contort her storytelling, as she draws attention to dates, instead of events and experiences. Slowly, the story becomes a product, still recognizable, but no longer belonging solely to her. One requirement of the paperwork required to file for asylum is to demonstrate that the applicant personally experienced violence, which means that it is not enough to show that the environment in a particular country is marked by violence or civil war, but one must prove that one personally experienced violence.

Shuman and Bohmer (2004) note:

> Each culture has its own concepts of courage, victimization, dignity, and persecution as well as different concepts and practices of bureaucracy. Whether trauma victims understand their plight as personal or as part of a larger

situation of political persecution is also culturally specific. Each of these concepts is, to a degree, translatable, but they are also embodied, cultural constructions further differentiated by local understandings of age, gender, and other identity markers. Further, both the genres of the applicant's home-land speech community and the cultural experience of being a refugee have an impact on the construction of asylum narratives.

(p. 402)

To do so, it must become a narrative that follows acceptable conventions that demonstrate that Chrisette's experiences of trauma, violence, and pain are some-how severe enough to qualify her to be here. During our interview, Chrisette argues that Haiti is no longer her home, because she can't go back. She notes "I can't go, and then – every friend I have – I know five people do the same job with me, they kill them. Shoot them. Shoot them like dog on the street because of a job." While she says this, she shows me a picture of the baby that passed away on her phone and continues by saying "this is my baby's eyes. Let me show you." At the time of the interview, I was struck by the fact that our discussion of "home," which I put into the title of this project and deemed to be central to my inquiry, could be so easily interrupted by seemingly unrelated photos and videos, as we went off track by discussing the birth weight and length of our children.

However, when I analyzed the data, it became clear to me that for Chrisette, the notion of a home that dissipated was also directly linked to her losing the child due to the violence she experienced. Home no longer exists for Chrisette, not only because she can't go back without being pointed out and finding herself in dan-ger, but also because her friends and colleagues were murdered, which would cut her off from her source of income. A few months after our interview, Hurricane Matthew destroyed her mother's house and left her estranged husband and other children displaced. The narrative of the violence she and others experienced, then, became both the reason for why Haiti no longer was her home and the reason her presence in the United States would be justified. Thus, one afternoon in July and months after her initial appointment with the organization that has agreed to help her, Chrisette tells me that she needs me to write her story for her. I wrote the fol-lowing note into my researcher journal:

Chrisette told me that she wanted me to write the story for her weeks ago, yet waited until this moment to give me the documents. I didn't know why she needed this at first, but from the documents I can glean that it is for her asylum process. A process we had initiated together, when I brought her to the nonprofit organization for which I volunteer. But also a process she dis-rupted when she thought she was getting married to a man she now says she doesn't remember.

[Field note, July 23]

I am sharing this excerpt, not to anchor this narrative chronologically, but to illustrate how so many of my interactions with Chrisette played out throughout the year and a half we lived next to each other; there would be months during

which nothing seemed to move ahead with respect to her efforts of pursuing visa documents, then there would be a sudden flurry of action, a kind of pressed immediacy during which she would call me, send several text messages, and expect me to respond to her requests of filling out or printing paperwork or giving her advice within hours. Often, she abandoned goals she had vigorously pursued before, for example she missed several appointments with her lawyer when she began communicating with an American man who indicated that he would marry her. Only a few weeks after she told me she didn't need the asylum narrative because of this union, I asked her about the man and she said she wasn't sure who I was talking about. In a way, this inconsistency and erratic approach to certain issues was very much evidence of the uncertainty that characterized her situation.

When she asked me to write her story, we met that same afternoon. She retold the story in French, telling me that it made her feel much more comfortable. I recorded her and crafted her story based on the recording. The following excerpt stems are from the narrative we co-crafted speaking, listening, and writing for the purposes of asylum. The organization that would file the request for asylum for her provided an informative sheet that asked for a detailed description of events, dates, and the trauma experienced. The first paragraphs of the narrative describe just that. Finally, Chrisette's asylum narrative concluded as follows:

> I am afraid for my life. I changed my phone number and address, but they always found me. I am easily recognizable because of my light skin and work in the public eye. I am convinced that these gangs will kill me if I return to Haiti. Since I left, 5 more journalists have been killed. My husband remains in Haiti with 2 of our children. Someone has recently sought them out with the intention of killing them, but they were observed by a neighbor and didn't succeed. Nevertheless, they have caused my husband and children to live in fear and move constantly.
>
> My newborn died in a hospital in (city). I know that the violence and fear I experienced during my pregnancy caused my child's untimely death. I bear the scars of the violence – and one particularly hideous bite mark – as a reminder that I am not safe. If I have to return to Haiti, I know I will experience more violence, all because I supported what I believe is right – a democratic government, freedom of speech, and support for those who need it most. Thank you for considering my case.
>
> [Text Data, July 27, 2016]

A number of things could be noted from the process of telling the story and crafting a written product intended to gauge whether or not an individual had experienced "sufficient" personally experienced violence to remain in the country: 1) it requires that a political asylum seeker tells the most harrowing parts of their experiences and aligns them chronologically (even if this is not the structure of telling that feels the most authentic to them); 2) the crafted narrative no longer solely belongs to the person who experienced it, but changes hands, is evaluated, and ultimately plays a deciding role in whether a person is allowed to remain in

the United States or not. According to Shuman and Bohmer (2004), the Bureau of Naturalization and Citizenship Services (the entity that reviews the asylum seekers' narratives and conducts interviews with them) requires that these narratives represent experiences of oppression and persecution in a style that is specific to U.S. culture.

Thus, the asylum seekers must craft a narrative that is credible according the standards of the Bureau of Naturalization and Citizenship Services, which requires those who write them to operate in a cultural code that presents the experiences of those who were persecuted in a way that follows its conventions. Although Chrisette had been primed to tell her story in this way by having to retell it time after time to different employees at the organization that agreed to help her, she was unable to write the narrative in a way that would have been convincing. Chrisette and other asylum seekers are expected to know and understand the writing conventions for this specific piece of writing, and are expected be able to write it in English (or find access to someone who is able to do so in their best interest).

Thus, crafting this narrative requires a particular kind of literacy that requires knowledge of a particular set of writing conventions. Usually, it does not suffice for the applicant to write the narrative by themselves. Rather, Shuman and Bohmer (2004) contend that the process usually depends on the processing officers' knowledge of the political situation of the applicant's country of origin and requires the involvement of lawyers or other experts, "who provide assistance to claimants fill a crucial role in reframing the claim not only to be consistent with the law, but also, to correspond with current Western social values, regardless of the merits of any particular claim" (p. 398). However, these social values are not consistent across Western culture, or even region, and therefore require localized knowledge. Consequently, undocumented immigrants who do not have access to legal support risk not being aware of the cultural constructs that drive the selection process.

After I finished writing the narrative, I dropped the envelope containing the three single-spaced pages off in front of Chrisette's apartment. A few days later she knocked on my door to tell me that she was extremely pleased with the narrative stating: "This is how I would write it if I had the words. I love it when I give someone a job and they do really well." Chrisette submitted the narrative along with other documents to the organization, but only a few weeks later abandoned the process of seeking asylum.

She told me that the organization did not move swiftly enough with respect to her case. Instead, she asked me to help her fill out the paperwork to request a green card based on family ties, since her brother is a U.S. citizen, a plan she also abandoned within weeks and finally asked me to write a letter to help her apply to the U.S. army, who, she assumed, would sponsor her green card. However, after a few minutes of research I found that undocumented immigrants are not eligible to enlist in the U.S. military. Then, Hurricane Matthew struck Haiti, and Chrisette sent me the following message:

The text message in Figure 4.3 further illustrates Chrisette's economic hardship, which is directly linked to her status as an undocumented immigrant. Her

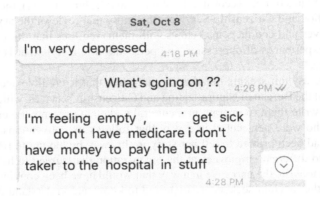

Figure 4.3 Text message exchange with Chrisette (lighter background)

feeling of emptiness is caused by her sick child and inability to be as mobile as she would like to be. On multiple occasions, Chrisette shared with me how much she would like a car, since she usually drove where she wanted to go in Haiti (she has proudly told me about her Jeep on several occasions). The bus was inconvenient at times not only due to its routes, but also because Chrisette was harassed on the bus twice. The police never showed up when she called them, despite the proximity of the bus stop to the police station, further adding to her feeling of being racially and economically deprived.

After the aforementioned text message, Chrisette goes on to tell me that Hurricane Matthew destroyed her mother's and sisters' homes. She says "I don't have the energy to do nothing." Thus, she not only has to process through the experiences and incidents that take place in her current life, but is also removed from her children and other family members in Haiti, because going back would put her in danger. Although she argued that home is no longer Haiti, because it signifies danger to her and remains a place she cannot go back to, the United States is also not constructed as a comforting home for her, since her life is in a constant state of limbo and transition.

Chrisette's experiences of being in the United States as an undocumented immigrant, then, truly embody the meaning of existing between horror and hope. While she knows that her life is in danger in Haiti, both due to natural disaster as well as political persecution, she is not exactly safe in the United States either. Positioned at the intersections of Black womanhood, undocumented legal status, limited English proficiency, and the resulting lack of economic opportunity, Chrisette now knows that the police do not show up when she calls them (which has happened twice over the course of 3 months) and that any chance of being exposed to the authorities as an undocumented immigrant or failing to provide a convincing narrative can lead to her deportation, which most certainly means that she will experience more violence. Her light skin privilege, which has been a

theme of discussion for all participants in this study in some way or another, may advantage her in the United States in some ways.

Since I have met Chrisette, she has always been employed, for example.

However, she knows that her same light skin makes her a target in Haiti, thereby putting her in more danger. Thus, although lighter skinned people have systemically afforded privilege in many cultures, Chrisette's story also indicates how complex skin tone privilege is when viewed transnationally and intersectionally. While light-skin was a theme discussed by all participants (either as a systemic privilege in Black communities, often tied to upward mobility and class status, or a way to distance oneself from harmful representations of Black identity), how this privilege manifests itself is quite context dependent. For Chrisette, her light skin may continue to afford her being heralded as an attractive Black woman, which may have economic benefits, but at the same time it is a marker of privilege that places her in direct danger of being identified should she have to return home voluntarily or by force.

"I am a racist now" – gendered transnational Black identity

Chrisette's identity as a Black woman is not only impacted by her skin tone and the discrepancy between her perceived and actual socioeconomic status in Haiti. Although she identifies as a Black woman, she has much to say about Black people in the United States. In the following excerpt, which is rather lengthy, Chrisette shares with me some of her thoughts about Blackness in America, which she had repeated to me before and after this incident, despite my attempts to challenge some of her perspectives, which I read as being problematic in their classed and gendered nature.

TANJA: Do you feel like your identity has changed since you came to the United States?

CHRISETTE: No.

TANJA: Because you said, before you didn't see yourself as a Black woman necessarily. Or did you see yourself as a Black woman in Haiti but people said you weren't, or how was that?

CHRISETTE: No, I explain you. Some poor people, they're angry. They see me like White.

TANJA: But you yourself –

CHRISETTE: For myself I know I'm Black. My mom is Black. My dad have the same color, light skin. If that say – I'm a Black girl. That's it.

TANJA: Right. So here, when you look at America and racism in America, how do you negotiate your Blackness, or how do you think about being Black now?

CHRISETTE: I can see I'm different. If I'm going to say – I'm not going to say I'm Black. Because, when I see like – when I dress, I took a shower. I change my look. I can say, I look like Spanish girl or Chinese girl [laughter], stuff like that. But I don't see – I see something different about the Black people and me, when I see them.

TANJA: Really?

CHRISETTE: Yeah, yeah. Because it's like, I see a little bit different. It's like, the smoking. And then I see a really big different, big different. It's not like I'm racist. I'm trying to tell the truth, what I see. And I see sometimes these person, I see they don't go to school.

TANJA: Here in the complex, you mean?

CHRISETTE: Yes.

TANJA: The people here, in the –

CHRISETTE: Yeah. They don't go to school. They're just staying on Facebook, drugs, sex, store. That's what I see. But me, I can say – I can sort of told you, I'm different with some people I see. But for other people, they're nice. Even their Black skin is nothing for me. I can see we're the same.

This paragraph highlights several points. For one, it shows that Chrisette, as a light-skinned Black woman, resists others' perceptions of her Blackness or identity. She quite clearly states "I'm a Black girl. That's it." However, her self-definition is one that is closely connected to her perceived class identity. She notes that it is "poor people" who impose a white identity onto her, even though she says she is no different from those poor people (in terms of socioeconomic status) earlier on in the discussion and that it is her skin tone that marks her perceived wealth. She notes "when I was in Haiti, I can survive. I don't have money. I try my best to survive. But because of my color, they think I'm a rich people. And then I have friends from the government, they know me." Interestingly, when I asked whether her estranged husband was also light-skinned, she notes that he is Black, and that, "they always said my husband, I don't love him. I just stay with him because of money, because he was [athlete][19], stuff like that." Although it is unclear who exactly "they" is, presumably they are the same people who were darker skinned and identifying her as white, and the complex and contradictory nature of Chrisette's racial identity becomes clear: Although she identifies as being Black, she points out that her husband "is Black," when asked whether he is lighter-skinned or not.

Further, as the aforementioned longer paragraph indicates, these perceptions are classed, as it is "Black poor people" who both impose the racial label onto her, threaten to kill her if she does not share her perceived wealth, and assert that her love for her dark-skinned husband must be driven by money. At the same time, she notes her potential of racial ambiguity as she can change her look to "look like a Spanish girl" or "Chinese girl," which may invoke stereotypical images of non-Black women of color. Although she does not explicitly state that the benefit in this racial ambiguity is to navigate spaces that are marked by anti-Black racism, particularly the assumption of deviance as it relates to Blackness, this interpretation is not a leap, since she follows her statement up by describing herself as being different from the Black people around her.

Thus, she describes the Black people she encounters in our neighborhood by describing stereotypical characteristics or behaviors such as poor education,

smoking, sexuality, and "going to the store", presumably to waste time or money, or for nefarious reasons. This is the type of Black person she would like to distinguish herself from.

Interestingly, she prefaces this notion with "I am not a racist" when describing the kinds of Black people she does not align herself with. Poor Black people and the behaviors and circumstances associated with them in Chrisette's description are different from "other" Black people, who are educated, presumably do not smoke, and are those with whom she can align herself.

Despite her assertion "I am not a racist," I invite Chrisette to my apartment only a few months later after having missed several text messages and phone calls, some of which sounded quite serious. As soon as I open the door, she argues: "I needed you yesterday! My world was ending." A sense of guilt sweeps over me; I was simply too focused on my own work and life to respond to her messages, particularly since they usually required some sort of labor on my part. However, she notes that all she needed from me was moral support, because her relationship, which had only begun a few months before, had ended in heartbreak. This relationship was the second relationship she had pursued in that year, much to the chagrin of her husband. Both men were Black from different parts of the diaspora, who were both naturalized citizens. After the second break-up, Chrisette decided that she was now "racist." I wrote down her words as she was talking, but did not record our exchange:

> Black men can no longer talk to me. I realize that he was able to treat me this way because of my situation. He says he is an American, but I told him, even if they naturalize me, I will always be a Haitian. I will better myself by going to school. Learn English first. I am now a racist. I told my boss at work: I know Black people were here, there is no tip and too much work. He asked if it was all Black people and I told him "yes." They are uneducated and rude and they will call you a bitch for no reason. He asked why I said that. I told him: My boyfriend mistreated me. So he said: Ok, one messed up. That means all of them are bad? I said *all*. [laughs]. I don't have a problem with Black women at all. But Black men. From now on, I am racist. [She touches her child]: You are no longer Black baby. I will change your color."
>
> [Interview notes, August 25, 2016].

I remember this exchange as a pivotal point in my perception of Chrisette, because she repeated them quite frequently after this exchange. Chrisette repeated her mantra of "I am now a racist" (always pronounced as French "raciste") over and over again. Although it was usually said accompanied by laughter and said jokingly, I was surprised to hear some of her sentiments about Black people, such as associating squalor and the absence of a tip with Black people's behavior. I came to know of Chrisette's deep-seated pain, which was the root cause of her commentary. From the distance of our Midwestern town, she watched as her husband started a new life in Haiti with her friend, as all attempts to find a partner in our region, a partner who may alleviate some of the burden on her, proved

difficult for her. Chrisette believes that improving her English and pursuing more education would shield her from being mistreated in relationships with Black men, particularly those who are protected by their American citizenship, while she inhabits the vulnerable sphere of the undocumented visa status. Although she earlier proclaimed that Haiti is not her home, she frequently reiterated pride in her Haitian national identity by noting that she will always be Haitian, even if she was naturalized.

Chrisette's energetic and dynamic personality and delivery often caught me off guard. I asked her if she had any hopes for things I should include in my research about her, and she told me she simply wanted me to tell her story – just in case she would be unable to do so herself.

Crystal Laura (2013) writes: "When qualitative researchers study people who we love, it means we test methodological boundaries, flip the script on method and technique, we fundamentally challenge what counts as data. In fact, love is a kind of data" (p. 289). Indeed, studying people who we love not only presents its own set of challenges, but may also produce love as data. As many academics, I have had to rebuild community wherever graduate school, postdoctoral work, or other positions guided me. Very little of the where and how felt within my control, and very little felt safe. One Sunday, after a tutoring session with Naima, a man followed me to my lone car in the parking lot. Naima had already left, and I looked around, not seeing a single person on the street other than the man. He began complimenting me, and when I politely declined and tried to get into my car, he attempted to pull me back out, reaching through my open window to unlock my door. When I managed to get my key into the ignition to turn my car on, he was still holding on, sweating, and now crying, begging me to stay. I drove off, shaking and rattled by how quickly a mundane Sunday afternoon had turned into what felt like a fight for survival. The incident cemented for me how alone I was as an international student, single and living alone. When I started this research project, which provided me with scheduled times to talk to friends and family with whom I did not previously talk often, these interactions helped me rebuild my community with purpose. The support and love that followed are not quantifiable but have had a lasting effect on me.

Thus, while we always must consider power in the research process, this consideration has to be made knowing that working within our own communities invites us to reenvision how we analyze power in our relationships.

Conclusion

In the foreword to Zora Neale Hurston's (2018) *Barracoon*, Alice Walker reflects on the true life story of Cudjoe Lewis, a man who was sold into chattel slavery and interviewed by Hurston in the 1920s:

> We see a man so lonely for Africa, so lonely for his family, we are struck with the realization that he is naming something we ourselves work hard to avoid: how lonely we are too in this still foreign land: lonely for our true culture, our people, our singular connection to a specific understanding of the Universe. And that what we long for, as in Cudjo Lewis's case, is gone forever.
>
> (Walker, 2018, p. xii)

Walker's invocation of remaining foreign and longing for one's people beautifully captures what could be considered a leitmotif of the Black diaspora. It certainly is a theme that rings true for the women who participated in the foundational study for this book. For us, women who navigate life at times between and, at other times, simultaneously within multiple spaces, there is no easy way to hold on to much of anything, as our homesteads, the places at which we are recognized and invited when we walk down the street, as Haki reminisced, or the place, where if you are out of rice or sugar your neighbor will gladly share it with you, are often foreclosed or "gone forever." Hurston's *Barracoon* was published in 2018, some 58 years after her death. It is not only a "Maestrapiece," as Alice Walker called it, or the "feminine perspective or part of a structure, whether in stone or in fancy, without which the entire edifice is a lie" (Walker, 2018, p. xi), but also a historical artifact that invites ethnographers and qualitative researchers from communities of color to think of the ways we do this work within our own communities. Hurston guides us through the horror and pain of Cudjoe Lewis' stories through the days on which he opted out of talking to her and those on which they sat side by side, sharing fruits and exploring the continuities of the past and present.

The stories the women shared for this study were often also gut-wrenching, and there were days on which no formal interviews could happen, even if they were scheduled. For instance I think of Naima's desperation when the 2017 Muslim immigration ban was signed by former President Donald Trump, while Naima's husband, sons, and mother were on their way to the United States. Naima's

DOI: 10.4324/9781003056621-6

husband and kids had gone to help her mother close her household for a perma-nent relocation to the United States after years of working through the immigra-tion process. They spent days in airports, not knowing when a plane would be able to return, while Naima was in the United States, 9 months pregnant and unable to get any accurate information. I spent hours at her home, calling different airlines upon her request, knowing no one would be able to give me additional informa-tion after what felt like a haphazard act of evil. After years of trying to get her mother to move in with her, it felt like a cruel joke that she was unable to make the final leg of her journey. I was elated for her when the family was reunited while the executive order was temporarily blocked, and her mother, a woman who had been living alone for years, was able to join her household. For now, Naima has pivoted. She decided against pursuing English as a Second Language and college education and is instead completing certificates and coding. Her original dreams deferred, she is finding ways to self-actualize and support her family after a decade of trying her best to pursue traditional paths.

Chrisette came so close to her goals of learning English and obtaining docu-mentation before going radio silent on Facebook and WhatsApp and disappearing from neighborhood. While I do not know what happened to her and her daughter, I think of her often, mourning her absence from my life, hoping that she is content and safe. I think of all the risks she took to provide for her children and family and all that she had to lose in the process. I think of the countless other women who migrate to create futures for themselves and their families.

Thinking through the women's stories from a Transnational Black Feminist perspective means having to attend to the contexts and histories that shape our lives. For me, these included the transnational dimensions present in my own life before I was even born, through my mother's migration story, as well as her mother's (the grandmother I share with Maya and Marisha) – and their foremoth-ers, who are descendants of enslaved Africans. Economic disenfranchisement and ongoing colonial exploitation prompted their desires or forced their hand to leave their homes and envision futures for themselves elsewhere, even temporarily. Haki's entire home village rallied around her to pay for her education, enabling her to go to college as one of the only girls in her region. She takes this knowledge and responsibility wherever she goes, even when she feels in this new country "you are suffering and nobody cares" (Haki, Interview).

All of the women underwent changes in perspectives and understanding as they navigated the particular racialized setting of the United States. As I was invested in understanding the processes of racialization, I found that the stories collected in this work revealed that many of the women described their Black identity devel-opment in relation to whiteness in the United States, rather than based on a pan-African shared cultural identity. However, this does not mean that discourses on Blackness and Black inferiority do not exist in the women's countries of origin. I am reminded of Naima, who explained that in her experiences in Somalia, Black-ness was definitely connected to understandings of inferiority and undesirability. As she explained, Blackness was seen as a West African trait and had direct con-sequences (e.g. job opportunities) for those whose skin tone and facial features

resembled a Black person in this context. In many ways, then, West Africanness, Blackness, and dehumanization through enslavement remain closely connected context. Colorism also had a direct impact on who could be married. Coming to America not only created a Black identity for Naima, but it also created a space for those of her friends and relatives who could not have married their partners, because of the racial hierarchies in Somalia to live free of the particular societal constraints of their home community. Thus, becoming Black in America, or seeking to understand racism in the America, means reckoning not only with becoming marginalized and dehumanized, but also with reconciling prior understandings of racialization with those particular to one's new context. At the same time, it also created small avenues of freedom and escape from racialized and classed oppression in other places and forged relationships across differences that no longer existed in the same forms.

Guinier (2004) and Rogers and Mosley (2006) argue that this understanding requires a conceptualization of race and racism as "an instrument of social, geographic and economic control of both Black and White" (Guinier, 2004, p. 114). This framework views racism as structural and racial literacy as a tool of engaging in public debates about race, which can be viewed as being productive for building a nuanced understanding of racialized experiences. For Black immigrant women, part of developing this racial literacy requires an understanding of the particular discourses and histories of race and gender in the United States and positioning themselves within these contexts.

A Transnational Black Feminist approach requires us to think beyond the nation-state to study migration (Amelina, Faist, & Nergiz, 2014). However, for transnational Black women, the nation-state is not a mere unit of spatial analysis. Instead, how the nation-state frames migration directly impacts the lives, experiences, and educational opportunities of the Black transnational women. Furthermore, the women's national identities, even if they were as difficult and contention-laden as Chrisette's Haitian identity, remained intact. Home to Haki, Naima, Marisha, Chrisette, and Maya will always be the geographical region and, in many ways, the nation they are from. On the other hand, Tee and Ama reflected a much more contentious and complex construction of home, much of which was mediated by the interconnection of whiteness and European-ness/Germanness.

It is for them that the work of Transnational Black Feminism, with its attention to (grand)daughtering and intersectionality, solidarity-building and interrogation of (post)colonial borders must continue in order to work essentialist notions about Blackness and womanhood.

References

Abu Sa'da, C., & Bianchi, S. (2014). *Perspectives of refugees on returning to Somalia.* Retrieved from: www.fmreview.org/crisis/abusada-bianchi.html

Alexander, M. J., & Mohanty, C. T. (1997). *Feminist genealogies, colonial legacies, democratic futures.* New York: Routledge.

Allen, R. L. (2001). The globalization of White Supremacy: Toward a critical discourse on the racialization of the world. *Educational Theory, 51*(4).

Amelina, A., & Faist, T. (2013). De-naturalizing the national in research methodologies: Key concepts of transnational studies and migration. In Amelina, A., Faist, T., & Nergiz, D. (Eds.). *Methodologies on the move: The transnational turn in empirical migration research.* New York: Routledge.

Amelina, A., Faist, T., & Nergiz, D. D. (Eds.). (2014). *Methodologies on the move: the transnational turn in empirical migration research.* New York, NY: Routledge.

Anthias, F. (2002). Where do I belong?: Narrating collective identity and translocational positionality. *Ethnicities, 2*(4), 491–514. doi:10.1177/14687968020020040301

Anthias, F. (2008). Thinking through the lens of translocational positionality: an intersectionality frame for understanding identity and belonging. *Translocations: Migration and social change, 4*(1), 5–20.

Ayim, M. (1995). *Blues in schwarz-weiß.* na.

Basarudin, A., & Bhattacharya, H. (2016). Meditations on friendship: Politics of feminist solidarity in ethnography. In Chowdhury, E., & Philipose, L. (Eds.). *Dissident friendships: Feminism, imperialism, and transnational solidarity.* ProQuest Ebook Central. Retrieved from: https://ntserver1.wsulibs.wsu.edu:2171

Berry, L. V. (1994). *Ghana: A country study.* Washington: GPO for the Library of Congress.

Blay, Y. A. (2008). All the "Africans" are men, all the "Sistas" are "American," but some of us resist: Realizing African feminism(s) as an Africological research methodology. *Journal of Pan African Studies, 2*(2), 58–73.

Boylorn, R. M. (2013). *Sweetwater: Black women and narratives of resilience.* New York: Peter Lang.

Brown, N., & Young, L. (2016). Ratchet politics: Moving beyond Black women's bodies to indict institutions and structures. In Mitchell, M., & Covin, D. (Eds.). *Broadening the contours in the study of Black politics.* New Brunswick: Transaction Publishers.

Burkhard, T. (2019). I need you to tell my story: Qualitative inquiry for/with transnational Black women. *Cultural Studies ↔ Critical Methodologies, 19*(3), 184–192.

Carlson, E. (2016). Anti-colonial methodologies and practices for settler colonial studies. *Settler Colonial Studies,* 1–22. doi:10.1080/2201473X.2016.1241213

Chowdhury, E. H. (2006). Global feminism. *Feminist theory's cul-de-sac. Human Architecture: Journal of the Socilogy of Self-knoweldge, IV (Summer 2006)*, 291–302.

Clandinin, D. J., & Connelly, F. M. (2000). *Narrative inquiry: Experience and story in qualitative research*. San Francisco, CA: Jossey Bass.

Coleman-King, C. (2014). *The (re-)making of a Black American: Tracing the racial and ethnic socialization of Caribbean American youth*. New York: Peter Lang.

Collective, C. R. (1986). The Combahee river collective statement. *Home girls: A Black feminist anthology*, 264–274. Latham, NY: Kitchen Table – Women of Color Press.

Collins, P. H. (1987). The meaning of motherhood in Black culture and Black mother-daughter relationships. *Sage*, *4*(2), 3.

Collins, P. H. (1990). *Black feminist thought: Knowledge, consciousness, and the politics of empowerment*. Boston: Unwin Hyman.

Collins, P. H. (2010). Black feminist thought in the matrix of domination. *Black feminist thought: Knowledge, consciousness, and the politics of empowerment*, 221–238.

Corbett, B. (1995). *The Haitian revolution*. Retrieved from: www.hartfordhwp.com/archives/43a/102.html

Couture, A. L., Zaidi, A. U., & Maticka-Tyndale, E. (2012). Reflexive accounts: An intersectional approach to exploring the fluidity of insider/outsider status and the researcher's impact on culturally sensitive post-positivist qualitative research. *Qualitative Sociology Review*, *8*(1), 86–105.

Crane, D., & Bovone, L. (2006). Approaches to material culture: The sociology of fashion and clothing. *Poetics*, *34*(6), 319–333.

Crenshaw, K. (1991). Mapping the margins: Intersectionality, identity politics, and violence against women of color. *Stanford Law Review*, *43*(6), 1241–1299.

Dai, Y. (2016). Bridging the divide in feminism with transcultural feminist solidarity: Using the example of forging friendship and solidarity between Chinese and U.S. women. In Chowdhury, E., & Philipose, L. (Eds.). *Dissident friendships: Feminism, imperialism, and transnational solidarity*, pp. 71–90. ProQuest Ebook Central. Retrieved from: https://ntserver1.wsulibs.wsu.edu:2171

Davies, C. B. (1995). *Black women, writing and identity: Migrations of the subject*. New York, NY: Routledge.

Dei, G. J. S. (2006). Introduction: Mapping the terrain- towards a new politics of resitance. In Dei, G. J. S & Kempf, A. (Eds.). *Anti-Colonialism and Education: The Politics of Resistance*. Leiden, The Netherlands: Brill.

Deiri, Y. (2018). But why do we need the bomber to be studying for a science test?: Racialized Arab femininities and masculinities. *Journal of Ethnic and Cultural Studies*, *5*(2), 89–97.

Delgado, R., & Stefancic, J. (2001). *Critical race theory: An introduction*. New York: New York University Press.

Dillard, C. B. (2012). *On spiritual strivings: Transforming an African American woman's academic life*. Albany, NY: SUNY press.

Diversi, M., & Moreira, C. (2009). *Betweener talk: Decolonizing knowledge production, pedagogy, and praxis*. New York: Routledge.

Dumas, M. J. (2016). Against the dark: Antiblackness in education policy and discourse. *Theory into Practice*, *55*(1), 11–19.

Dunbar, C., Rodriguez, D., & Parker, L. (2001). Race, subjectivity and the interview process. In Gubrium, J., & Holstein, J. (Eds.). *Handbook of interview research: Context and method*. London, UK: Sage.

El-Tayeb, F. (2011). *European others: Queering ethnicity in postnational Europe*. Minneapolis, MN: University of Minnesota Press.

Errante, A. (2000). But sometimes you're not part of the story: Oral histories and ways of remembering and telling. *Educational Researcher, 29*(2), 16–27.

Essien-Udom, E. U. (1962). *Black nationalism: A search for an identity in America*. Chicago: University of Chicago Press.

Evans-Winters, V. E. (2019). *Black feminism in qualitative inquiry: A mosaic for writing our daughter's body*. Abingdon, UK: Routledge.

Everet alt, J. E., Marks, L. D., & Clarke-Mitchell, J. F. (2016). A qualitative study of the Black mother-daughter relationship: Lessons learned about self-esteem, coping, and resilience. *Journal of Black Studies, 47*(4), 334–350.

Galster, G. (1990). Racial steering by real estate agents: Mechanisms and motives. *The Review of Black Political Economy, 19*(1), 39–63.

Glesne, C. (1997). That rare feeling: Re-presenting research through poetic transcription. *Qualitative Inquiry, 3*(2), 202–221.

Glick Schiller, N., Darieva, T., & Gruner-Domic, S. (2011). Defining cosmopolitan sociability in a transnational age: An introduction. *Ethnic & Racial Studies, 34*(3), 399–418.

Gordon, D. B. (2003). *Black identity: Rhetoric, ideology, and nineteenth-century Black nationalism*. Carbondale: Southern Illinois University Press.

Guillaumin, C. (1992). Rasse. Das Wort und die Vorstellung. In Bielefeld, U. (Ed.). *Das eigene und das Fremde*. Neuer Rassismus in der alten Welt? (159–173) Hamburg, Germany: Junius.

Guinier, L. (2004). From racial liberalism to racial literacy: "Brown v. Board of Education" and the interest-divergence dilemma. *Journal of American History, 91*(1), 92–118.

Hall, K. M. (2016). A transnational black feminist framework: Rooting in feminist scholarship, framing contemporary black activism. *Meridians, 15*(1), 86–105.

Hall, K. M. Q. (2019). *Naming a transnational Black feminist framework: Writing in darkness*. Abingdon, UK: Routledge.

Hancock, A.-M. (2004). *The politics of disgust: The public identity of the welfare queen*. New York: New York University Press.

Harris, F. (2014). The rise of respectability politics. *Dissent, 61*(1), 33–37.

Harrison, J., MacGibbon, L., & Morton, M. (2001). Regimes of trustworthiness in qualitative research: The rigors of reciprocity. *Qualitative Inquiry, 7*(3), 323–345.

Harushimana, I., Ikpeze, C., & Mthethwa-Sommers, S. (2013). *Reprocessing race, language and ability: African-born educators and students in transnational America*. New York: Peter Lang.

Hochschild, J. (1995). *Facing up to the American dream: Race, class, and the soul of the nation*. Princeton: Princeton University Press.

Hodges, D. J. (2005). Problematizing blackness: Self-ethnographies by Black immigrants to the United States. *American Anthropologist, 107*(3).

Höhn, M., & Klimke, M. (2010). *A breath of freedom: The civil rights struggle, African American GIs, and Germany*. New York: Palgrave Macmillan.

Hurston, Z. N. (2018). *Barracoon: The story of the last "black cargo"*. New York: Amistad.

Hurtado, A. (2003). Theory in the flesh: Toward an endarkened epistemology. *International Journal of Qualitative Studies in Education, 16*(2), 215–225.

Ibrahim, A. (2014). *The rhizome of blackness: A critical ethnography of hip-hop culture, language, identity and the politics of becoming*. New York: Peter Lang.

Jamaica Information Service. (2017). *The history of Jamaica*. Retrieved from: http://jis. gov.jm/information/jamaican-history/

James, C. L. R. (1963). *The Black Jacobins: T'oussaint L'Ouverture and the San Domingo revolution*. New York: Random House.

Konadu-Agyemang, K., Takyi, B. K., & Arthur, J. A. (2006). *The new African diaspora in North America: Trends, community building, and adaptation*. Lanham, MD: Lexington Books.

Larrabee, M. J. (2016). *An ethic of care: Feminist and interdisciplinary perspectives*. New York, NY: Routledge.

Laura, C. T. (2013). Intimate inquiry: Love as "data" in qualitative research. *Cultural Studies? Critical Methodologies, 13*(4), 289–292.

Malinowski, B. (2013). *Argonauts of the western Pacific: An account of native enterprise and adventure in the archipelagoes of Melanesian New Guinea [1922/1994]*. New York: Routledge.

Massey, D. S., Mooney, M., Torres, K. C., & Charles, C. Z. (2007). Black immigrants and Black natives attending selective colleges and universities in the United States. *American Journal of Education, 113*(2), 243–271.

Migration Policy Institute. (2015). *RAD diaspora profile: The Kenyan diaspora in the United States*. Retrieved from: www.migrationpolicy.org/research/selectdiaspora-populations-united-states

Montopoli, B. (2008). *Obama: "Brothers should pull their pants up"*. Retrieved from: www.cbsnews.com/news/obama-brothers-should-pull-up-their-pants/

Moore, A. R. (2013). *The American dream through the eyes of Black African immigrants in Texas*. Lanham, MD: University Press of America.

Morgan-Trostle, J., & Zheng, K. (2016). *The state of Black immigrants*. Retrieved from: www.stateofBlackimmigrants.com/assets/sobi-deportation-sept27.pdf

Nash, J. C. (2018). *Black feminism reimagined: After intersectionality*. Durham, NC: Duke University Press.

Njoku, R. C. (2013). *The history of Somalia*. Santa Barbara, CA: Greenwood.

Oguntoye, K., & Lorde, A. (1986). *Farbe bekennen: Afro-deutsche Frauen auf den Spuren ihrer Geschichte*. Frankfurt am Main, Germany: Fischer-Taschenbuch Verlag.

Okpalaoka, C. L., & Dillard, C. B. (2012). (Im)migrations, relations, and identities of African peoples: Toward an endarkened transnational feminist praxis in education. *Educational Foundations, 26*, 121–142.

Paris, D., & Winn, M. T. (Eds.). (2013). *Humanizing research: Decolonizing qualitative inquiry with youth and communities*. Thousand Oaks, CA: Sage Publications.

Patterson, R. J. (2013). A triple-twined re-appropriation: Womanist theology and gendered-racial protest in the writings of Jarena Lee, Frances E. W. Harper, and Harriet Jacobs. *Religion & Literature, 45*(2), 55–82.

Pessar, P. R. (2003). Transnationalism and racialization within contemporary U.S. immigration. In Hintzen, P. C., & Rahier, J. M. (Eds.). *Problematizing blackness: Self-ethnographies by Black immigrants to the United States*. New York: Routledge.

Plummer, K. (1983). *Documents of life: An introduction to the problems and literature of a humanistic method*. London: Unwin Hyman.

Rahier, J. M., & Hintzen, P. (2014). *Problematizing blackness: Self ethnographies by black immigrants to the United States*. Routledge.

Rahier, J. M., Hintzen, P. C., & Smith, F. (Eds.). (2010). *Global circuits of blackness: Interrogating the African diaspora*. Champaign, IL: University of Illinois Press.

Rhee, J. E. (2021). *Decolonial feminist research: Haunting, rememory and mothers.* Abingdon, UK: Routledge.

Refugees and asylum. USCIS. (2015, November 12). Retrieved from https://www.uscis.gov/humanitarian/refugees-asylum

Rogers, R., & Mosley, M. (2006). Racial literacy in a second-grade classroom: Critical race theory, whiteness studies, and literacy research. *Reading Research Quarterly, 41*(4), 462–495.

Sakamoto, A., Woo, H., & Kim, C. H. (2010). Does an immigrant background ameliorate racial disadvantage? The socioeconomic attainments of second-generation african americans. *Sociological Forum, 25*(1), 123–146.

Schmelz, A. (2009). *The Ghanaian diaspora in Germany its contribution to development in Ghana.* Eschborn, Germany: Deutsche Gesellschaft für Technische Zusammenarbeit (GTZ) GmbH. Retrieved from: www.migration4development.org/sites/m4d.emakinaeu.net/files/The_Ghanaian_diaspora_in_Germany.pdf

Shuman, A., & Bohmer, C. (2004). Representing trauma: Political asylum narrative. *Journal of American Folklore, 117*(466), 394–414.

Sleeter, C. E. (2001). Preparing teachers for culturally diverse schools: Research and the overwhelming presence of whiteness. *Journal of Teacher Education, 52*(2), 94–106.

Smith, L. T. (1999). *Decolonizing methodologies: Research and indigenous peoples.* London: Zed Books.

Thomas, K. (2012). *A demographic profile of black Caribbean immigrants in the United States.* Migration Policy Institute. Retrieved from: www.migrationpolicy.org/research/CBI-demographic-profile-blackcaribbean-immigrants

Vickermann, M. (1999). *Crosscurrents: Caribbean immigrants and race.* New York: Oxford University Press.

Tuck, E., & Yang, K. W. (2012). Decolonization is not a metaphor. *Decolonization: Indigeneity, Education & Society, 1*(1).

Walker, A. (2018). Foreword. In *Barracoon: The story of the last "black cargo".* New York: Amistad.

Waters, M. C. (1999). *Black identities: West Indian immigrant dreams and American realities.* New York: Russell Sage Foundation.

Weems, L. (2006). Unsettling politics, locating ethics: Representations of reciprocity in postpositivist inquiry. *Qualitative Inquiry, 12*(5), 994–1011. doi:10.1177/1077800406288628

Wimmer, A., & Glick Schiller, N. (2002). Methodological nationalism and beyond: nation–state building, migration and the social sciences. *Global networks, 2*(4), 301–334.

Wolff, R. (1970). Economic aspects of British colonialism in Kenya, 1895 to 1930. *The Journal of Economic History, 30*(1), 273–277. Retrieved from: www.jstor.org/stable/2116744

Zhou, M. (1997). Growing up American: The challenge confronting immigrant children and children of immigrants. *Annual Review of Sociology, 23*, 63–69.

Index

Note: Page numbers in **bold** indicate a table on the corresponding page.